COMIC BOOK GUY'S
BOOK OF POP CULTURE

THE SIMPSONS™ LIBRARY OF WISDOM
COMIC BOOK GUY'S GUIDE TO POP CULTURE

HarperCollins*Entertainment*
An imprint of HarperCollins*Publishers*
77–85 Fulham Palace Road
Hammersmith, London W6 8JB
www.harpercollins.co.uk

Published by HarperCollins*Entertainment* 2005
1 3 5 7 9 8 6 4 2

ISBN 0 00 720815 4

Printed in Belgium by Proost NV, Turnhout

Publisher: Matt Groening
Creative Director: Bill Morrison
Managing Editor: Terry Delegeane
Director of Operations: Robert Zaugh
Art Director: Nathan Kane
Special Projects Art Director: Serban Cristescu
Production Manager: Christopher Ungar
Production/Design: Karen Bates, Art Villanueva
Staff Artists: Chia-Hsien Jason Ho, Mike Rote
Production Assistant: Nathan Hamill
Administration: Sherri Smith
Legal Guardian: Susan A. Grode

THE SIMPSONS™ LIBRARY OF WISDOM
Conceived and Edited by Bill Morrison
Book Design and Production by Serban Cristescu
Contributing Editor: Terry Delegeane
Research and Production Assistance: Nathan Hamill

Contributing Artists:
Karen Bates, John Costanza, Melanie Cristescu, Serban Cristescu, Mike DeCarlo, John Delaney, Becca Emanuel Luis Escobar, Nathan Hamill, Nathan Kane, Mike Kazaleh, Jorge Laurenco, Istvan Majoros, Bill Morrison, Kevin M. Newman, Phil Ortiz, Andrew Pepoy, Mike Rote, Kevin Segna, Robert Stanley, Eric Tran, Doug Whaley

Contributing Writers:
James W. Bates, Evan Dorkin, Scott M. Gimple, Jesse L. Mccann, Bill Morrison, Tom Peyer, Ty Templeton, Patric M. Verrone

Special Thanks to:
Pete Benson, N. Vyolet Diaz, Deanna MacLellan, Helio Salvatierra, Mili Smythe, and Ursula Wendel

COMIC BOOK GUY'S BOOK OF POP CULTURE

HarperCollins*Entertainment*

An Imprint of HarperCollins*Publishers*

THE COMIC BOOK GUY'S POP CULTURE TOP 40

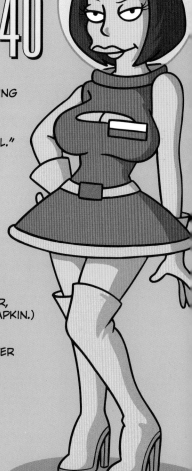

1. THE GREAT ONE-HANDED COMIC BOOK READING FOODS (BURRITOS, PIZZA SLICES, BURGERS, CHALUPAS, AND PEZ).
2. BEA ARTHUR'S VIRTUOSO PERFORMANCE AS ACKMENA IN THE "STAR WARS HOLIDAY SPECIAL."
3. SUCCESSFULLY REMOVING SCOTCH TAPE THAT ACCIDENTALLY CATCHES COMIC BOOKS WHEN REMOVING THEM FROM MYLAR BAGS.
4. EXTERMINATING EWOKS IN *STAR WARS* VIDEO GAMES.
5. FAST FOOD PROMOTIONAL MOVIE TIE-INS.
6. THE PLACE WHERE I DO MY NEVER-ENDING BATTLE AGAINST IGNORANCE, BAD TASTE, AND CONTINUITY INACCURACIES: THE INTERNET.
7. BEING RIGHT.
8. MY LUNCH WITH MARK WAID AT THE SPRINGFIELD COMIC-CON. (ACTUALLY, WE STOOD IN LINE TOGETHER AT THE SNACK BAR, BUT AT ONE POINT, HE DID ASK ME FOR A NAPKIN.)
9. THE ART OF FILKING.
10. MY MUPPET PELT JACKET.
11. MY HARD-FOUGHT FLAME WAR VICTORIES OVER THE LIKES OF LIEFELDFANATIC*227*, SOLOSHOT*7*ST, AND WILLOWWATCHER*26*.
12. THE HYPNOTIC FAUX-BROGUE OF MR. JAMES "SCOTTY" DOOHAN.
13. SAYING THE WORD *DOOHAN*.
14. GUT-WRENCHINGLY GOOD FANFIC.
15. MIND-BLISTERINGLY AWFUL FANFIC.
16. ARGUING WITH A VERY CALM VOICE AND MY ARMS FOLDED, UTTERLY CONFIDENT OF MY INTELLECTUAL AND AESTHETIC SUPERIORITY.

17. MY BEARD. NOT ONLY DOES IT ALLOW ME TO AVOID THE DRUDGERY OF DAILY SHAVING, BUT SOME SAY I RESEMBLE A *FIRST CONTACT*-ERA JONATHAN FRAKES.
18. THAT MOMENT, EARLY IN THE MORNING, AS I OPEN THE DOOR TO MY STORE AND GET HIT WITH THE PULPY, INKY, MILDEWY SMELL THAT IS *12,837* VINTAGE COMIC BOOKS.
19. UTTERLY DOMINATING THE ENTERTAINMENT CATEGORY IN TRIVIAL PURSUIT.
20. MY HOURS SPENT DISCUSSING THE POTENTIAL RAMIFICATIONS OF PITTING POWERFUL FICTIONAL BEINGS AGAINST EACH OTHER IN BATTLES TO THE DEATH.
21. *RADIOACTIVE MAN* #488, "RADIOACTIVE MAN VERSUS CAPTAIN SOLAR!"
22. IGNORANT PEOPLE AT GARAGE SALES SELLING PRICELESS COMIC BOOKS, TOYS, AND COLLECTIBLES AT WELL BELOW PRICE GUIDE PRICES.
23. ESCALATORS.
24. ANIME IN ITS ORIGINAL JAPANESE.
25. BOOTH BABES.
26. CORRECT CHANGE.
27. WOMEN WHO MEASURE DISTANCES IN PARSECS.
28. JAPAN, FOR ITS COMIC BOOK LITERACY RATE, GODZILLA, VIDEO GAMES, AND POCKY — MY MAIN SOURCE OF RIBOFLAVIN.
29. LIMITED EDITION ANYTHING.
30. DVD EXTRAS.
31. THE CHURRO CART ON CONCOURSE C OF THE SPRINGFIELD CONVENTION CENTER.
32. *"KRACKA-THOOM!"* BEST COMIC BOOK SOUND EFFECT EVER.
33. RENAISSANCE FAIRES.
34. ORIGINAL PACKAGING.
35. DEEP-FRIED FUNYUNS.
36. EXTRA-WIDE SEATS AT THE SPRINGFIELD GOOGOLPLEX.
37. MY MENTOR, T. M. MAPLE. (GOOGLE IT!)
38. THE TERM *SENSES-SHATTERING*.
39. KNOWING THAT I AM IMPROVING THIS NATION'S LITERACY AND KNOWLEDGE OF CORRECT POWER RING OPERATION.
40. INTRODUCING A YOUNG PERSON TO THE WONDER AND JOY THAT IS GRAPHIC STORYTELLING AND THEN SHOWING THEM EVERYTHING THAT IS WRONG WITH IT.

A TYPICAL DAY IN THE LIFE

10:00 a.m. - Comic Book Guy wakes at crack of midday to sound of Ren & Stimpy alarm clock blaring, "Get up, you eeediot!" over and over. Wonders for thousandth time if waking to object calling him idiot every morning is good for self-esteem.

10:15 a.m. - Opts for body spray once-over, in lieu of shower.

10:30 a.m. - Breakfasts on jumbo egg/potato microwave burritos. Eats six, all the while scoffing at their past-expiration dates. Experiences post-breakfast queaziness.

10:45 a.m. - Makes last-minute bid on eBay for Anna Kournikova's sports bra—and wins!

11:00 a.m. - Feeling extraordinarily good, decides to clear Krustyburger bags/wrappers out of Chevy Geo. Quits after filling first garbage bag.

11:15 a.m. - Enjoys satisfying drive to Android's Dungeon; notes other motorists' positive reaction to new "If You Believe in the Force, Honk My Horn!" bumper sticker.

11:30 a.m. - Opens store half hour late, clearly pleased line of people are inconveniently waiting.

11:35 a.m. - Unloads boxes of new comics from car, bringing each in as slowly as possible. Anxious customers finally volunteer to unload/unpack/count/rack comics for him. Score!

IF YOU BELIEVE IN THE FORCE HONK **MY** HORN!

ACTION1

OF COMIC BOOK GUY

:00 p.m. - Convinces elderly woman to sell late son's pristine, tensive comic collection for five cents each. Says he is doing her favor, since they are so old.

:15 p.m. - Starts getting cranky. Customers bring inkies to appease him.

2:30 p.m. - Happy to finally get his "Borg Do It Collectively" T-shirt mail. Puts it on immediately. Brief glimpse of his naked rso/man-bosoms frightens pesky moms out of store.

2:45 p.m. - Comic fan Mr. T happens by while passing through ringfield. Shames him into autographing four hundred unsold pies of *Mr. T and the T-Force* comics. Wryly quips, "I pity the fool" Mr. T drives away with dangerously cramped fingers.

1:30 p.m. - Receives joyous news that Frodo's of Shelbyville has gone out of business. To celebrate, offers everyone in store fifty cents off *Biclops* #1 from LensCrafters.

2:00 p.m. - Trades four autographed, "ultra rare" *Mr. T and the T-Force* comics to unbalanced man for deed to acre of land on the outskirts of town. Contemplates opening his own Renaissance Faire come Spring.

2:15 p.m. - Closes for lunch, accidentally locking comic supplier's representative inside store.

2:30 p.m. – Waiting in line at Taco Mat when frustrated sole employee quits. Once alone, makes himself one dozen special tacos and four extra-large soft drinks. Stuffs pockets with Kiddie Meal toys. Enjoys free lunch in park while watching exercise class suffer through calisthenics.

2:45 p.m. - Discovers grocery store vending machine accepts pogs in place of dollar coins. Returns to his shop with armload of Almond Joy.

3:00 p.m. - Eats candy while striking bargain with comic supplier's representative through mail slot. Agrees to free him for additional 5% discount on next month's order.

3:15 p.m. - Prank calls Stan Lee. "Excelsior!"

3:30 p.m. - Puts new reprints of classic comics in direct sunlight so UV rays will give them "classic look" to increase "value."

3:45 p.m. - Child brings him extremely rare gold-foil Popeye trading card found outside store. Instantly recognizes it as part of collection he appraised earlier. Deduces owner must have dropped it. Now faces difficult moral decision: should he give kid kickback for bringing it to him? Tosses kid copy of *Biclops* #1 and sends him away.

4:00 p.m. - Convinces several children to buy old *Star Wars* Pez dispensers accidentally melted by leaving over floor heater. Claims they are rare *Episode III* character, Nin Compo'op.

4:15 p.m. - Receives call. Gets last-minute invite to replace sick judge at Capital City Fantasy Costume Competition. Exhilarated to toss lookiloos out of store and close two hours and forty-five minutes early.

4:30 p.m. - Goes home to change into tuxedo T-shirt.

4:45 p.m. - Picked up by fellow judge, David Hasselhoff look-alike with own KITT car that actually talks (thanks to William Daniels voice impressionist in trunk). Good times continue to roll!

5:15 p.m. - While speeding along Capital Highway, spots wanted criminal in next lane fleeing from police. Caught up in moment, makes uncharacteristic leap into stolen car. Sits on thief's lap until he surrenders.

6:00 p.m. - Arrives at Fantasy Costume Competition already hero, thanks to evening news. Takes place at judging table.

6:05 p.m. - Realizes fellow judge sitting next to him is none other than Jessica ("Dark Angel," *Fantastic Four*) Alba. Not sure, but thinks Jessica Alba is winking at him suggestively.

7:00 p.m. - Wins Fantasy Costume Competition door prize– life-size, working Batmobile. Doctor in audience helps him until he's steady on feet again.

8:30 p.m. - Attends post-competition gala. Winners of Group Award, three women dressed as "Farscape" characters, suggest he bring the Batmobile around to take them someplace quieter—his apartment.

9:00 p.m. - Intergalactic rolling in hay commences. Just when thinking day couldn't get any better, doorbell rings. It is Jessica Alba. She has pizzas.

11:00 p.m. - Once girls asleep, flips on TV just in time for beginning of "Land of the Giants" marathon. Determines this to be "Best...Day...Ever!"

11:05 p.m. - Things begin to get fuzzy. Surroundings take on dream-like state. Girls disappear. Hallucinates that he is in giant wrapper—his expiration date has passed. Shouts, "Nooooo!" No sound comes out. Everything goes black.

11:30 p.m. - Wakes in hospital, where he has been unconscious all day. Stomach pumped earlier—bad burritos determined to be cause of illness.

11:35 p.m. - Angrily thinks of proper words for situation (in Klingon), "Ghuy'cha', qu'vatlh taHqeq!"

TO DO LIST

1. Wake up whenever.
2. Think about the opposite sex.
3. Recite the Green Lantern Oath.
4. Check eBay auctions.
5. Shower/shave.
6. Skip shower/shave if something good is on Cartoon Network.
7. Self-medicate with food.
8. Find a shirt that doesn't smell too bad.
9. Tivo "Smackdown," "Alias," "Battlestar Galactica," "Lost," "30-Minute Meals."
10. Find someone to help push-start car.
11. Open store.
12. Check eBay auctions.
13. Insult customers.
14. Read comics.
15. Bag comics.
16. Call lawyer about that Lynda Carter thing.
17. Call Frodo's of Shelbyville and ask for nonexisting manga titles.
18. Ban that Simpson punk from the store.
19. Send scathing letter to "Entertainment Weekly" for giving the "Elektra" DVD a C−.
20. Work on Klingon translation of "Atlas Shrugged."
21. Close store when it gets dark to save on electricity.
22. Buy Happy Meals in seemingly futile attempt to complete "The Incredibles" toy set.
23. Go home—eat Happy Meals.
24. Check eBay auctions.
25. Build up GA-Magog Planetbuster Demon Ape Gundam mecha kit.
26. Update blog--delete contentious posts from the foolish rabble.
27. Chuckle at the ineptitude of the world.
28. Download "Tentacle Monsters vs. Magical Schoolgirls" adult anime.
29. Create new and more invincible "EverQuest" campaign character.
30. Briefly question one's own sanity.
31. Send hate mail to eBay auction winners.
32. Play "EverQuest" until fabled Morpheus beckons me to his netherworld of dreams.
33. Wake up whenever.

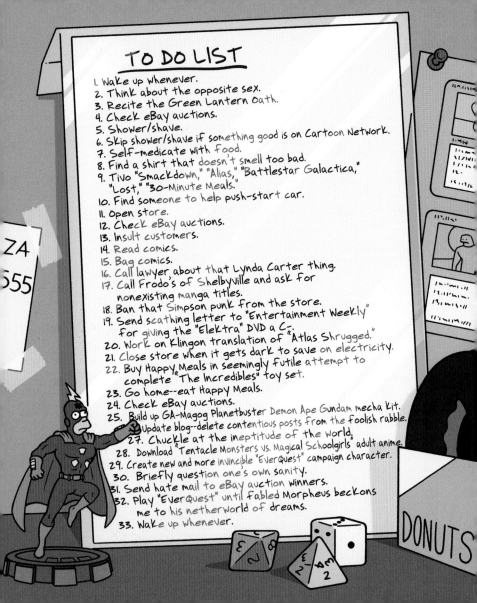

CBG'S GREATEST QUOTES OF ALL TIME!

"The Force is strong in this one." Darth Vader, *Star Wars*

"It's clobberin' time!" The Thing, *Fantastic Four*

"That's it, man! Game over, man! Game over!" Pvt. W. Hudson, *Aliens*

"I'll be back." The T800 Terminator, *The Terminator*

"I see dead people." Cole Sear, *The Sixth Sense*

"Finish him!" *Mortal Kombat* video game

"Back off, man. I'm a scientist." Peter Venkman, *Ghostbusters*

"No time for love, Dr. Jones!" Short Round, *Indiana Jones and the Temple of Doom*

"I've got a bad feeling about this." Han Solo, *Star Wars*

"Be afraid. Be very afraid." Veronica Quaife, *The Fly* (1986)

"Bite my shiny metal ass." Bender, "Futurama"

"Why do you say this to me, when you know I will kill you for it?" General Zod, *Superman II*

"In space, no one can hear you scream." *Alien* (movie poster)

"Let's you and him fight." Wimpy, *Thimble Theatre*

"'Tis but a scratch." The Black Knight, *Monty Python and the Holy Grail*

"I would never lie. I willfully participate in a campaign of misinformation."
Fox Mulder, "The X-Files"

"With great power there must also come great responsibility." Stan Lee, *Amazing Fantasy* #15

"Be excellent to each other!" Bill and Ted, *Bill and Ted's Excellent Adventure*

"Bust a deal, face the wheel." Aunty Entity, *Mad Max: Beyond Thunderdome*

"I don't believe in the no-win scenario." Admiral James T. Kirk, *Star Trek II: The Wrath of Khan*

"Shazam!" Captain Marvel (No, not Gomer Pyle, you louts.)

"I like pink very much, Lois." Superman, *Superman: The Movie*

"I yam what I yam." Popeye, *Thimble Theatre*

> ANYONE WHO THINKS *THEY* CAN COME UP WITH A BETTER LIST CAN *EAT MY SHORTS!*

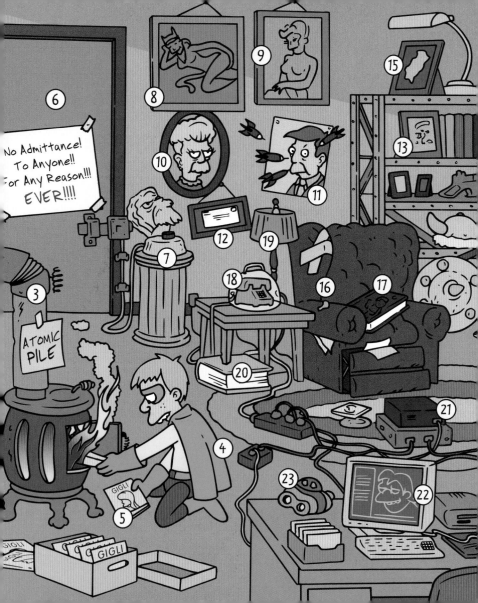

THE BACK ROOM OF THE ANDROID'S DUNGEON

1. Unsold copies of the comic adaptation of "Gigli."
2. Emergency provisions.
3. Atomic pile.
4. Temp/sidekick/aide-de-camp/partner-in-peril.
5. More unsold copies of "Gigli."
6. Fortress of toilet-tude.
7. Switch hidden in bust of Alan Moore opens door to fortress.
8. Catwoman shrine.
9. Seven of Nine shrine.
10. Agnes Skinner shrine.
11. Hall of Villains.
12. Official "No-Prize" signed by Stan Lee's brother, Larry Lieber.
13. VG minus condition copy of "Blackhawk" #300 —guest-starring and autographed by REO Speedwagon.
14. In case of bankruptcy—emergency copy of "Radioactive Man" #1.
15. Wet-nap used by Margot Kidder.
16. Reading chair stuffed with unsold copies of "Gigli."
17. "The Complete Richie Rich" volume 17.
18. Hot line to Doughie Joey's Pizza.
19. Lamp (blinks when pizza arrives).
20. "The Complete Works of Shakespeare."
21. Planetary monitor (making bootleg copies of "Battlestar Galactica 1980" marathon).
22. Electronic crime file (stores data on customers banned from store).
23. Viewmaster 3-D slides of store inventory (for insurance purposes).

LO! THERE SHALL BE A GUIDE TO COMIC BOOK RETAILING!

IF YOU READ ONLY ONE GUIDE TO COMIC SHOP RETAILING THIS YEAR—THIS IS THE ONE!

LESSON ONE: WHAT YOU'LL NEED TO RUN A SUCCESSFUL COMIC SHOP

1. A run-down, out-of-the-way location with dirt-cheap rent.
2. Comic books.
3. Comic boxes.
4. Comic bags.
5. Scotch tape.
6. Duct tape (for E-Z store repairs).

7. Baseball cards.
8. Autographed baseball (genuine or not).
9. Credit cards (as many as possible).
10. Parents' checkbook.
11. Cash register or large cigar box.
12. Some singles and a few quarters and maybe some dimes.
13. A TV.
14. A working inventory system. (Relax! Only kidding!)

LESSON TWO: MONEY AND FINANCE

While running a successful comic shop you will often find yourself months behind on your bills. Don't panic! Just remember to always pay your bills in the following order (if/when you do pay them):

1) Comic book distributor. (Duh! No comics, no comic shop.)
2) Phone. (Phone turned off? Borrow a customer's mobile in an emergency.)
3) Electricity. (Power shut off? Close the store when it gets dark outside.)
4) Heat. (Chilly? Put on a few extra comic book T-shirts.)
5) Water. (Who drinks water?)
6) LOW ON CASH? Raid the Comic Book Legal Defense Fund charity tin.

IMPORTANT!

Always tip the kid who brings the take-out or the little creep will spit in your chimichangas. (Tip with comics if possible.)

LESSON THREE: HOW TO AVOID GETTING UP FROM BEHIND THE COUNTER

- Yell across the store.
- Bury your face behind a comic.
- Avoid making eye contact with customers.
- Use a laser pointer to show customers where things are.
- Tell them, "We don't carry it!" until they go away.
- Stare fixedly at the TV.
- Pretend to be asleep.

LESSON FOUR: BOOTLEG MERCHANDISE

- Rule #1 of bootleg merchandise: There is no bootleg merchandise.
- Keep bootleg merchandise behind counter.
- Devise elaborate secret code/handshake for bootleg customers.
- Remember Rule #1.

LESSON FIVE: GENERAL INFORMATION

- Febreze store every month or two.
- Never throw anything away. It might be worth something someday.
- Good rule of thumb on changing the bags on your wall display comics: If it's yellow, let it mellow. If it's brown, take it down.
- Never let them see the price guides.

LESSON SIX: STORE SETUP

Forget buying expensive fixtures and shelving for your shop. All you need are some comic boxes and a little imagination!

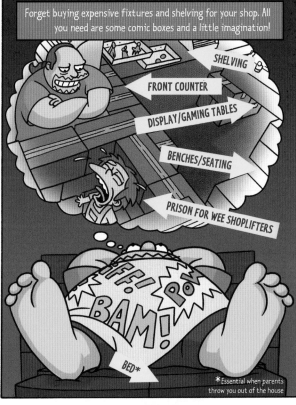

SHELVING

FRONT COUNTER

DISPLAY/GAMING TABLES

BENCHES/SEATING

PRISON FOR WEE SHOPLIFTERS

BED*

*Essential when parents throw you out of the house

And that's it! Your comic book mecca is all set, effendi!
Just open the doors and watch the success flow in like The Blob!
(The 1958 original, not the inferior remake.)

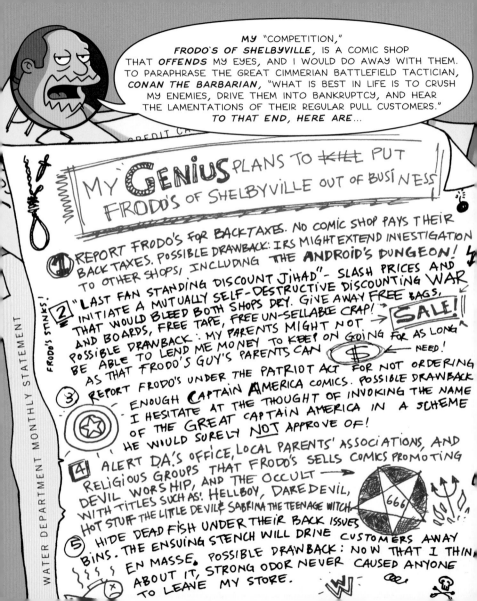

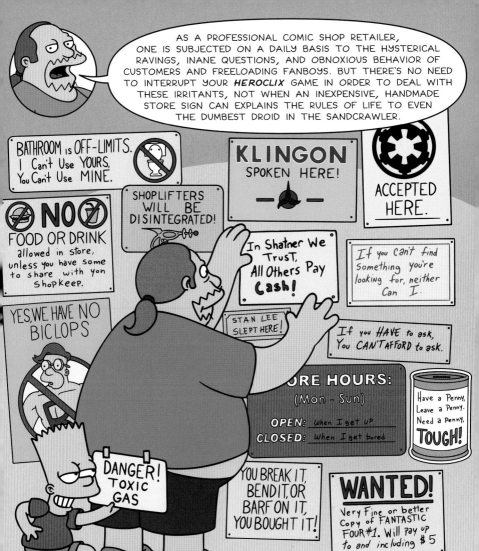

THE LEGION OF STUPEFYING CUSTOMERS

KID CLUELESS

DO YOU HAVE THE COMIC WHERE THE BIG GUY FIGHTS THE OTHER BIG GUY?

CREEPY GIRL

I'M LOOKING FOR COMICS WITH AMPUTATION SCENES IN THEM.

COMPLAINT KID

WHY DID THEY KILL BLUE BEETLE? HE WAS MY FAVORITE.

WHY ARE COMICS SO EXPENSIVE?

WHY DOES IT SMELL SO BAD IN HERE?

STINKY MONEY BOY

HOLD ON :SNORT!: I GOT ANOTHER DOLLAR IN MY OTHER SOCK.

KID 20 QUESTIONS

WHY DOESN'T SPIDER-MAN EAT FLIES?

CAN MR. FANTASTIC STRETCH TO INFINITY?

WHY DO THE HULK'S PANTS ALWAYS TURN PURPLE?

WHY DIDN'T BATMAN'S PARENTS TAKE A CAB?

SPECULATOR LAD

ARE THESE GONNA BE WORTH ANYTHING? WHAT'S HOT? I WANNA KNOW WHAT'S HOT!

DAY CARE KID

MY MOMMY WILL BE BACK TO GET ME AT 5:00. WILL YOU PLAY WITH ME?

ARGAIN BOY

IF I BUY A LOT OF STUFF, DO I GET A DISCOUNT? IF I PAY CASH, CAN YOU DROP THE TAX?

BACK ISSUE OPENING BOY

I JUST WANTED TO SEE IF LYCRA-GIRL WAS IN THESE ISSUES. SHE'S NOT. SO I DON'T WANT THEM.

HOPLIFT LAD

WHAT?

BARTMAN

NO BARTMAN COMICS?

OKAY, THAT'S IT! STORE'S CLOSED! EVERY-BODY OUT!

ID CAN'T-HOLD-IT-IN

TOLD YOU I HAD O GO!

GREETINGS, POP CULTURISTS! DADDY WARBUCKS ONCE SAID, "FILLING YOUR SURROUNDINGS WITH SPECTACULAR THINGS IS THE BEST WAY TO MAKE A SPECTACLE OF YOURSELF." THEREFORE, TO POINT YOU TO THE FINER THINGS IN LIFE, I PROUDLY PRESENT THE...

...BEST APARTMENT EVER

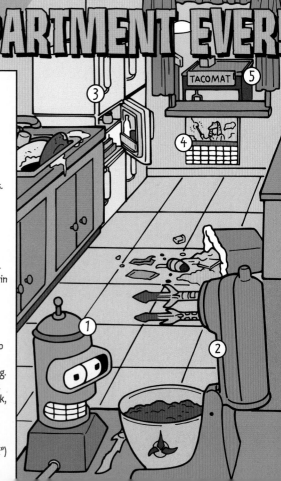

1. Bender blender.
2. Klingon 4-speed cake mixer with different attachments. ("'Qapla'soj!' That is Klingon for 'mighty tasty!'")
3. Wall of snacks.
4. "Stargate SG-1" 360-day, four-month wall calendar.
5. Convenient location near city hot spots.
6. The captain's chair.
7. "Zardoz" floating head hanging lamp.
8. Life-size inflatable Jar Jar Binks doll.
9. Wookiee-skin rug.
10. Vulcan nerve pinch coat rack.
11. Betty & Veronica three-way comforter.
12. Secret fold-away bed activator (hidden in bust of Shakespeare).
13. Ridiculously overpriced pop art.
14. Cerebro computer clutch.
15. TARDIS police call box.
16. "Terminator" "I'll Be Back" door sign—to display when you're out.
17. "Dungeons & Dragons" RPG vinyl flooring.
18. Ultimate entertainment center w/LP & 45 rpm quadraphonic turntable, 8-track, compact cassette, reel-to-reel stereo, Betamax, laser disc, and Edison's wax cylinder players. ("If it doesn't play on one of these, it's not that entertaining.")

TACOMAT

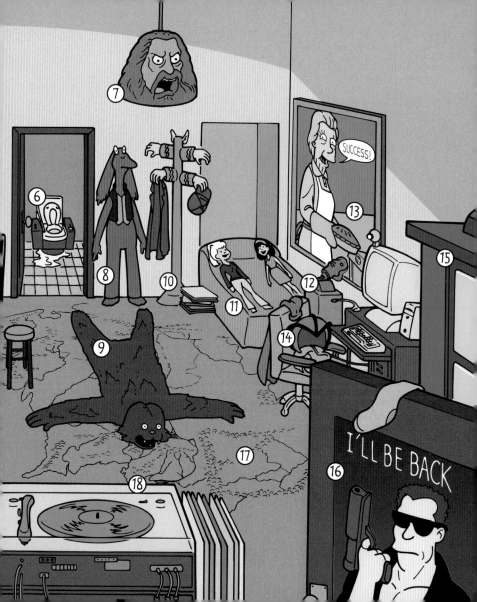

WITHOUT A DOUBT, TELEVISION IS A VAST, DUNE-LIKE WASTELAND, SORELY LACKING IN CREATIVITY, VISION, AND FEMALE WRESTLING. IF ONLY THE TV GENIE WERE TO APPEAR BEFORE ME, SUCH WONDERS I WOULD WREAK UPON THE AIRWAVES, WONDERS SUCH AS THESE CABLE CHANNELS, THE LIKES OF WHICH NO FAN OR WOMAN HAS EVER SEEN!

CBG'S DREAM NICHE CABLE CHANNELS

1. **THE DIRTY CARTOON NETWORK**
 "Mature Cartoons for Childish Adults"

2. **THE DARK ARTS AND ENTERTAINMENT CHANNEL**
 "All Things Magical, without the Ridicule"

3. **COMIC BOOK AND BASEBALL CARDS HOME SHOPPING NETWORK**

4. **STAR TREK: THE NEXT CABLE NETWORK**
 "Where No Cable Network Has Gone Before"

5. **WOMEN'S WRESTLING NETWORK**
 "All-Women, All-Wrestling, All Under 140 Pounds!"

6. **THE JUNK FOOD NETWORK**
 "You Are What You Watch"

7. **EEEEE! HORROR ENTERTAINMENT NETWORK**
 "The Network That's Horrible On Purpose"

8. **SETI TV – The Official Network for the Search for Extra-Terrestrial Intelligence**
 "We Are Not Alone, Despite What Our Ratings Might Say"

9. **THE ALTERNATE HISTORY CHANNEL**

10. **ESPN 3**
 "All Gaming Tournament Coverage, All the Time"

11. **BLOOMBERG COMIC BOOK BUSINESS NEWS NETWORK**
 "Hard-Hitting Comic Book News – As It Happens!"

12. **THE CONSPIRACY CHANNEL**
 "Remember, When You're Watching Us – They're Watching You!"

13. **SF/X**
 "The Network for Special Effects Enthusiasts"

14. **AMERICAN BOOTLEG CLASSICS**
 "No Schedule Available. We'll Be in Touch."

15. **ALL! JAPANESE! RUBBER! SUIT! MONSTER! ATTACK! CHANNEL!!!**
 "Please to Be Watching the All-Out Mayhem to Our Civilization!"

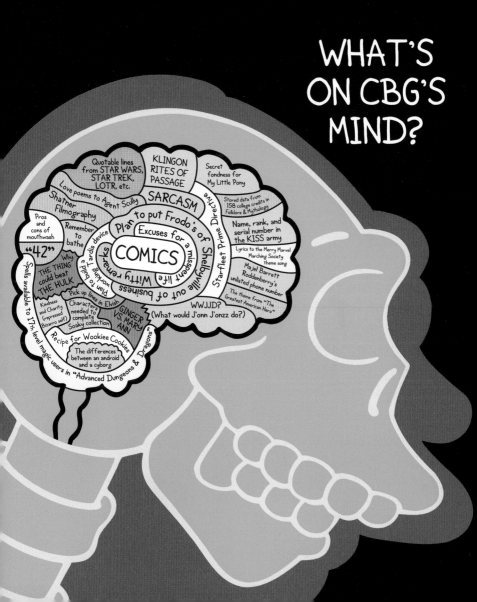

WHAT'S ON CBG'S MIND?

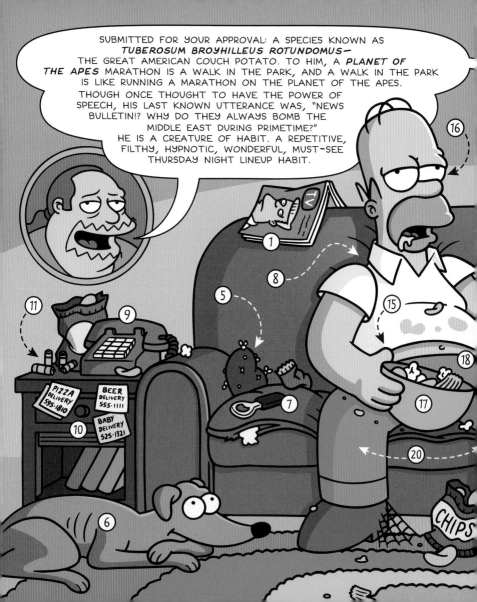

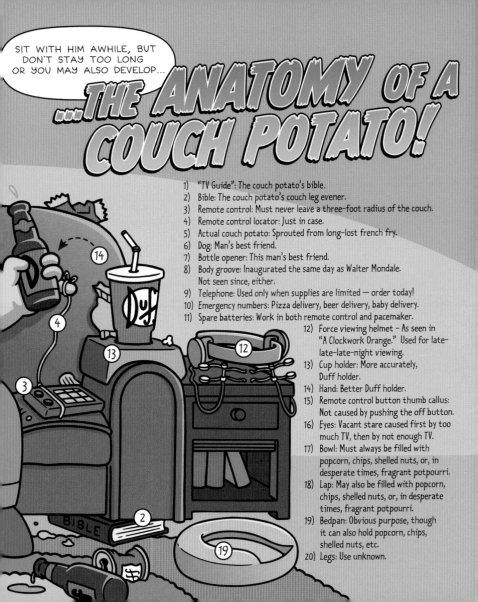

They say, "Music hath charms to soothe a savage breast." Well, then, ears front, True Believers! Here then are the many collectible sounds for the Comic Book Guy's many incorrigible moods! For, lo, there shall be...

CBG'S BEST EVER FAVORITE ALBUMS

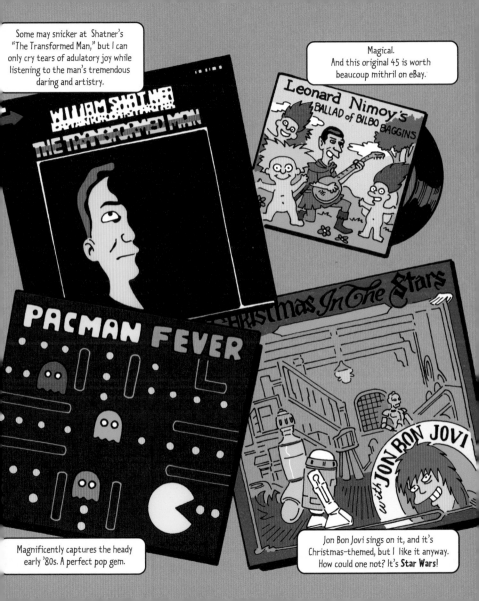

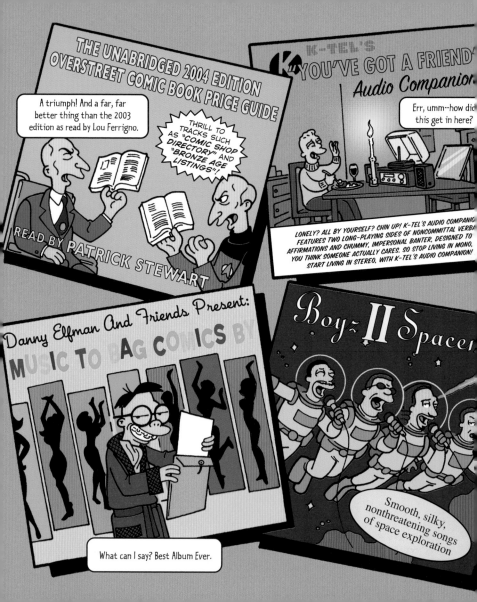

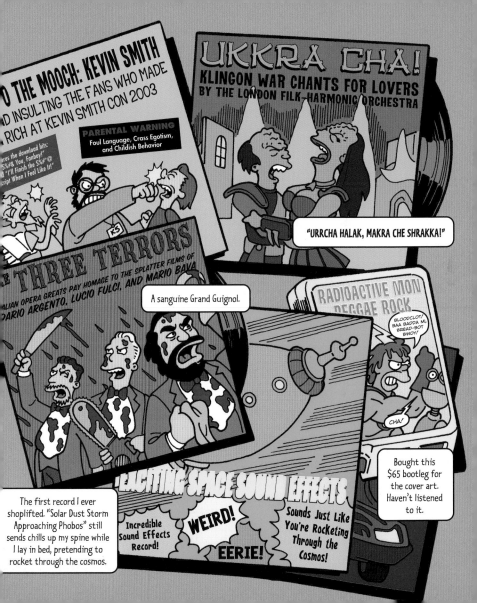

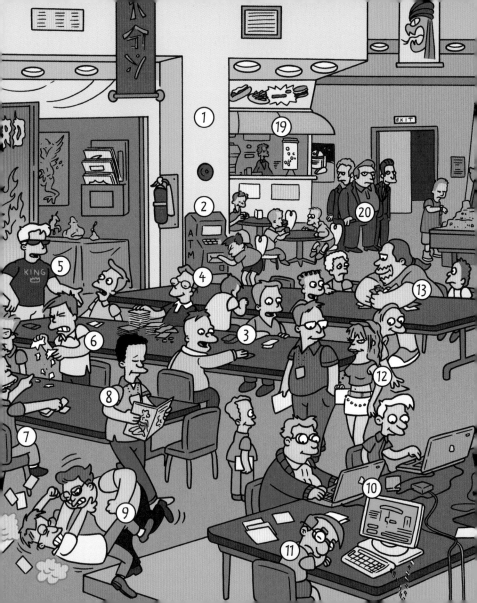

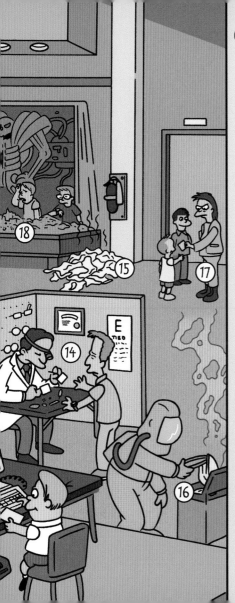

CBG PLACES TO BE

GAMING TOURNAMENT

1. No windows, no clocks (just like Vegas!).
2. ATM (emptied within first hour of tournament).
3. Gamers who spent at least $500 to compete for a grand prize worth $100.
4. Despised rich kid with the mithril to buy killer rare cards.
5. Lone alpha male.
6. Sore loser.
7. Sore winner.
8. Tournament judge.
9. Dueling wizards.
10. "Medieval Dead Merc Force 2: Die, Elf, Die!" online game.
11. Online player deep "in the zone" (or dead).
12. "The girl." ("You know, THE GIRL! Look! LOOK! Wait, don't, she's looking this way!")
13. Adult cheerfully fleecing ten-year-old out of his cards.
14. Thick black eyeglass repair station.
15. Discarded sweaty T-shirt pile.
16. Soiled shorts hamper.
17. Game company rep handing out free starter card packs ("First one's free!").
18. "D&D" campaign that took so long to set up there's no time left to play.
19. Gaming supply/snack concession (credit cards, debit, first-born accepted).
20. Underworld entrepreneurs looking to move in on the town's newest racket.

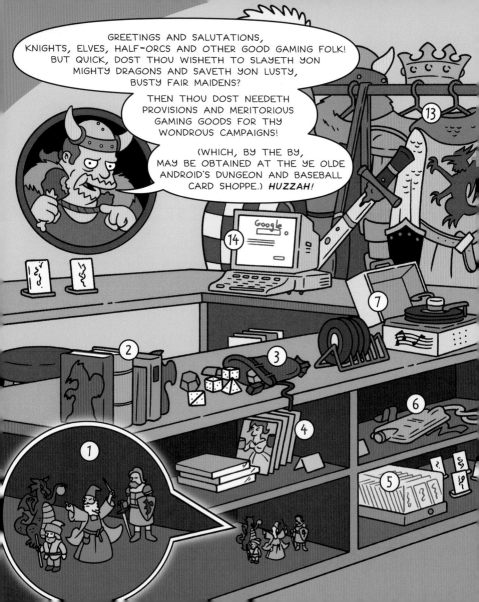

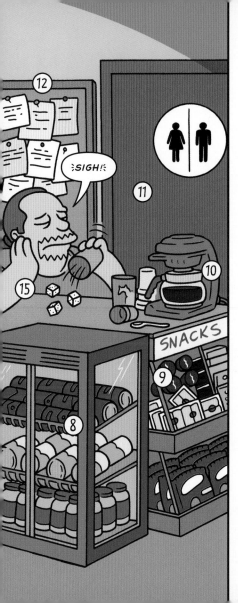

ESSENTIAL GAMING EQUIPMENT

1. Lead miniatures.
2. Reference and rule books—personally amended ("Dungeon Master's Guide," "Monster Manual," "Pervert Pamphlet").
3. Dice (All kinds! Four-sided, eight-sided, twelve-sided, twenty-sided, percentile, 100-sided, loaded percentile).
4. Mood video (a DVD of "Lusty Busty Barmaidens of Yore #9" is my personal favorite).
5. "Magic: The Gathering" cards too valuable to actually play with (for showing off during breaks).
6. Catheter with thigh collection pouch (for marathon gaming sessions).
7. Mood music ("LOTR" soundtracks, "Tales from Topographic Oceans" by Yes, anything by Jethro Tull).
8. Nectar of the demigods (Yoo-hoo).
9. Snacks of the gods (Doritos, Bugles, Funyuns, Combos, marshmallow Peeps, malted milk balls, Hot Pockets).
10. Caffeine supply.
11. Working toilet with toilet paper (or back issues of "Wizard's World Weekly").
12. Important phone #s (Domino's, Chinese food delivery, car service, Gary Gygax's home phone number to resolve arguments over the rules, Mother).
13. Period costumes and weaponry ("peace bonded" to avoid injury during arguments over the rules).
14. Google (for resolving arguments over the rules, and starting others).
15. Other people to play with (not present).

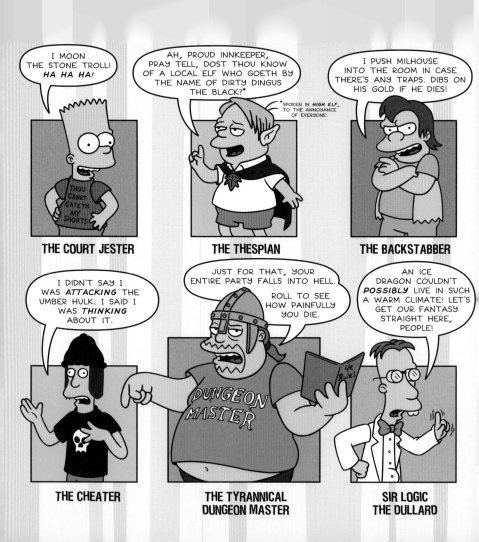

FANTASY GAMERS

THE OBSESSIVE
BUT I CANNOT DIE! I AM *WOTAR! WOTAR! WOTAR THE INVINCIBLE!*

THE RULE OGRE
I KNOW THE RULES ON MEAD DRINKING AFFECTING COMBAT AGAINST HALF-HALFLINGS IS HERE SOMEWHERE! JUST TALK AMONGST THYSELVES.

LORD HIGH BLOODSPORT
I *KILL* EVERYBODY, THEN I CUT THEM OPEN AND SEARCH THEIR GUTS FOR TREASURE! *YAAAAH!*

THE VIRTUAL LECH
AREN'T THERE ANY *WENCHES* IN THIS DUNGEON? C'MON, WHERE ARE THE *WENCHES*? LET ME ROLL FOR *WENCHES!*

THE STONER
HUH? OH, SORRY, DUNGEON MASTER DUDE, I WAS JUST THINKIN' 'BOUT VALHALLA AN' STUFF.

THE GIRLFRIEND TRYING TO PLEASE HER BOYFRIEND
EXCUSE ME, BUT CAN I LEAVE? I THINK I'M GOING TO BE SICK.

WHEN IT COMES TO ONE'S CHOICE OF WARDROBE, THE TRULY SAVVY AND FASHIONABLE FANBOY CAN EASILY COME UP WITH THE *APPROPRIATE POP CULTURE* T-SHIRT FOR ANY EVENT OR OCCASION. SIMPLY FOLLOW MY SARTORIAL EXAMPLE, AND YOU'LL BE ON THE CUTTING EDGE OF COMFORTABLE NONCONFORMITY. (AND, BY THE BY, THESE SHIRTS ARE *AVAILABLE* IN A VARIETY OF SIZES AT THE ANDROID'S DUNGEON AND BASEBALL CARD SHOP).

PUBLIC SPEAKING ENGAGEMENT

WORK

CELEBRITY SIGNINGS

CHURCH

THE T-SHIRT FROM THE BACK OF THE CLOSET

FAMILY GET-TOGETHERS

MALL EXCURSIONS

BEAM ME UP SCOTTIE, THERE'S NO INTELLIGENT LIFE HERE!

VISITING LOVED ONE IN HOSPITAL AFTER AN OPERATION

ALIEN

MOVIE OPENING

ADMIT ONE FAN

ROMANCE (WHERE NO FANBOY HAS GONE BEFORE!)

AS SUPERMAN HAD HIS LOIS LANE, AND GREEN LANTERN HIS CAROL FERRIS, SO SHALL WE ALL FIND OUR OWN TRUE LOVE, HOPEFULLY, SOMEDAY. TO HELP YOU WITH YOUR SEARCH, TRUE BELIEVERS, I WILL UNLOCK MY WAREHOUSE OF SECRETS AND IMPART TO YOU WHAT I KNOW. IT WILL TAKE THE NEXT FOUR PAGES, AND THERE MAY BE HOMEWORK.

IMPORTANT TIP!!!

Learn to estimate one hundred yards, that being the standard distance dictated in most restraining orders.

♥ PART ONE: HOW TO MEET A WOMAN AND SWEEP HER OFF HER FEET

BEST PLACE TO MEET WOMEN?

Bus: **NO**

Supermarket: **NO**

Town hall: **NO**

Your workplace: **LORD, NO**

Their workplace (waitresses, cashiers, lady cops): **NO**

Comic conventions: **FAT CHANCE**

Other than booth babes and snack bar workers, there are no women at comic conventions.

THERE IS NO BEST PLACE, BUT VULCAN LOGIC DICTATES THERE ARE NO WORST PLACES EITHER!

EXCELSIOR!

WHAT SORT OF WOMAN TO ASK OUT?

Someone old enough not to be choosy and young enough to be free of life-sustaining apparatus (such as an iron lung).

Avoid females in "mint condition," as they are high-maintenance companions. Stick with "lost staple," "page missing," or "reading copy" women.

Ideally, you want a widower or divorcée comfortable with the term "ready to settle."

NOW THAT YOU HAVE IDENTIFIED YOUR TARGET, MOVE IN FOR THE KILL WITH THESE *TOP TEN PICK UP LINES*

10) Would you like to come back to my place and watch some DVDs? If you're lucky, I'll show you my bonus features!

9) If I told you that you have the body of Xena, Warrior Princess, would you hold it against me, pausing first to don this authentic Xena costume I just happen to have with me?

8) KAH'LESS, G'GRAKTA AK'TUTH AKT'DA AHG! (translated from the Klingon: "By Kah'less, I would slay a hundred men to see you naked.")

7) Somebody had better call Odin, because Asgard is missing a Valkyrie warrior!

6) I just used the Force and visualized you in a skimpy gold metal bikini.

5) Come with me if you want to live!

4) And now for something completely different...me!

3) I'm tired of being Han Solo. Let's you and me form a Rebel Alliance.

2) To the Batcave, otherwise known as my parents' basement!

1) Is this a limited edition diecast Klingon Bird of Prey replica in my pocket, or am I just happy to see you?

It is important to make a strong
FIRST IMPRESSION
when you arrive for your date. Not everyone instantly geneto-bonds to their potential life partner, like Captain Picard did with his "Perfect Mate" or the Human Torch with his shape-shifting love-Skrull.

2 ## GROOMING:
Wash, but **don't** shave. Chicks dig beards. Think Willie Nelson or Wolverine.

Pull hair into a SINGLE ponytail (I stress SINGLE). Later, you may remove the scrunchy to unleash your inner TARZAN.

3 ## CLOTHING:
A T-shirt is a mood ring with armholes. It lets your date know where you're coming from, so choose wisely. This lightning bolt motif creates an air of mystery, letting her know your mood but also posing a question. Are you identifying with the Flash, the T.H.U.N.D.E.R. Agents, or the original Captain Marvel?

She will be intrigued all night until you reveal the answer!

4 ## GIFT:
The gift says, "Thank you for being seen with me in public."
Women seem to like flowers, candy, or steaks. Personally, I like to offer a 5% discount coupon from my comic book store, which guarantees I'll see her again.

5 ## SHOES:
Women notice things like shoes. Be sure to wear some.

♣ PART THREE: WHAT TO DO ON A DATE ♣

1

Read comics and discuss them at length. Would the Flash's super speed make him a lousy lover? Can Batman write off his Batarang expenses and Batmobile mileage without revealing his secret identity? The topics are endless!

2

Go to the movies. Today's glut of superhero films and scarcity of chick flicks puts the odds of having an entertaining evening in your favor.

3

Watch last week's slate of TiVoed TV shows. Embrace modern entertainment technology while embracing your beloved. (But don't forget to share some with your date.)

4

Stand in line for things. The longer the line, the more time you'll have to bloviate on various topics, thus impressing your date and everyone else with your incredible knowledge.

5

Enjoy a romantic dinner of fried chicken by the bucket and Goldfish crackers (food of the gods!). Put the soundtrack to "Big Top Pee Wee" on the stereo if you want to put her in the mood!

6

Mend costumes. It's called multitasking, people!

7

Begin an Internet flame war. Impress each other with your fearless propensity for hurling anonymous insults! (Bonus! Getting hot and bothered on the Net can lead to getting hot and lucky in the bedroom!)

8

Bag and grade things. What could be more stimulating than this? 'Nuff said!

DATING IS NOTHING LIKE VIRTUAL SIM-GAME DATING. IN *REAL* LIFE, YOUR PARTNER HAS TO BE INTERESTED IN YOU AND "*IN THE MOOD*."

FOOD AND DRINK:

Every woman I have ever been with has told me later that alcohol "sealed the deal." Beware. You cannot drink wine with just ANY foodstuff without appearing foolish. Here is a chart of appropriate edible/potable combinations.

RED WINE	WHITE WINE	CHAMPAGNE	SPARKLING ROSÉ	SCOTCH
Burgers	Chicken bucket	Toast	Macaroni	Rejection
Bacon	Cheetos	Cereal	Peanut butter	Heartbreak
Corn chips	Popcorn	Eggs	Ice cream	Fries
Pork rinds	Marshmallow Fluff	Pancakes	Chocolate	
Tacos	Fries	Cool Whip	Fries	
Fries		Beer		
		Fries		

CAN YOU TEACH ME THE "SMOOTH MOVES"?

No. The "smooth moves" cannot be taught, they can only be OBSERVED in the behavior of better men and imitated. The following is a chart of the greatest ladies' men the galaxy has ever known, and what should be copied from each man's individual style:

Captain James T. Kirk	Boyish charm
James Bond	Roguish manner
Han Solo	Lopsided grin
Bruce Wayne	Brooding athleticism
Tony Stark	Flashy style
Magnus, Robot Fighter	Robot-fighting ability

THAT CONCLUDES THE LESSON. NOW HERE'S YOUR *HOMEWORK* ASSIGNMENT. STAY IN TONIGHT, AND WATCH *STAR TREK II* AND *III* AND JAMES BOND'S *YOU ONLY LIVE TWICE*.

AND STUDY ARCHIE'S WAY WITH THE LADIES IN ANY ISSUE OF *BETTY AND VERONICA*.

GOOD LUCK, AND *MAY THE MOJO BE WITH YOU!!!*

CBG PLACES TO BE
PARENTS' BASEMENT
—THE '80s

1. Sweet, sweet old school model glue.
2. Bagged and unplayed "D&D" module collection.
3. Super Nintendo with Super Mario cartridge.
4. Chewbacca the Doggie (R.I.P.).
5. Bootleg movies – "Empire Strikes Back," "Weird Science," "Secret Garden."
6. Worst "Automan" episode ever.
7. Closet filled with comics.
8. Betamax ("The preferred fan format of the future").
9. Movie posters stolen from theater lobbies.
10. Aurora Monsters of the Movies models.
11. Autographed Mookie Wilson baseball stolen from cousin.
12. Spider-Man phone that never rings.
13. Shrine to William Shatner.
14. Frank Frazetta barbarian print.
15. Kenner "Star Wars" action figures arranged by release date.
16. Superman dartboard.
17. "Battlestar Galactica" sheets.
18. Bagged "Starlog" collection.
19. Bagged "Fangoria" collection.
20. Squishee stains.
21. Marshmallow Peeps.
22. Upstairs and out of sight—Mom, sobbing quietly.
23. Invisible to the eye—the unmistakable stench of loneliness.

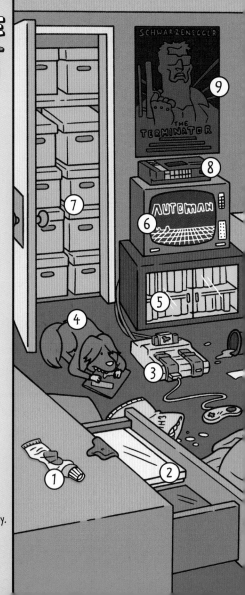

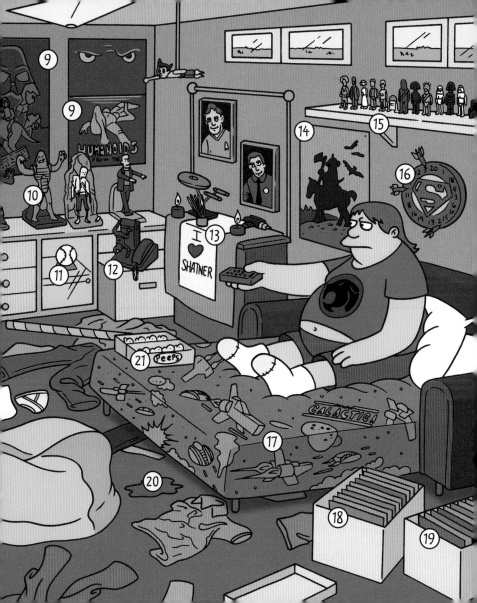

CBG'S WORST LINES EVER!

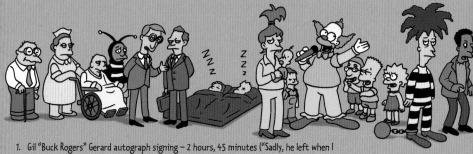

1. Gil "Buck Rogers" Gerard autograph signing – 2 hours, 45 minutes ("Sadly, he left when I was next in line.")
2. Line to view open casket of Plasmo the Mystic creator Dick Mortimer, 7/1/2002 – 2 hours, 47 minutes
3. San Diego Comic Con check-in – 8 hours
4. San Diego food concession line – over 3 hours
5. San Diego Comic-Con bathroom – 2 1/2 hours ("I didn't quite make it. Ruined a great Wolverine costume.")
6. Springfield Civic Auditorium (for "Conquest of the Planet of the Apes on Ice" tickets) – 4 hours
7. Free "Burger-Fingers" giveaway at Krusty Burger – 5 hours
8. Springfield General Hospital emergency ward – 12 hours (I threw my back out attempting to lift a box of unsold "Battlefield Earth" merchandise)
9. Medieval Times 10th Anniversary "All You Can Conquer" Royal Pig Roast and Go-Go Scullery Maid-a-Thon – 4 hours, 50 minutes
10. Toys "R" Us midnight release of "Enter the Matrix" video game, 5/14/2003 – 7 hours, 12 minutes
11. Toys "R" Us customer service counter to return "Enter the Matrix" video game, 5/14/2003 – 6 hours, 30 minutes
12. Kwik-E-Mart lottery line – 9 hours, 22 minutes ("The $183 million jackpot would have gone to building my dream Android's Castle.")
13. Phone company customer service center – 6 hours ("I swear to Zod, I never got those five disconnect notices.")
14. "Star Wars: The Phantom Menace" opening day ticket line – 3 weeks
15. "Star Wars: Attack of the Clones" opening day ticket line – 12 Days
16. "Star Wars: Revenge of the Sith" opening day ticket line – 17 hours ("I was pelted with Qui-Gon-Jinger Snaps™ and exiled for revealing the film's ending that I had read online.")

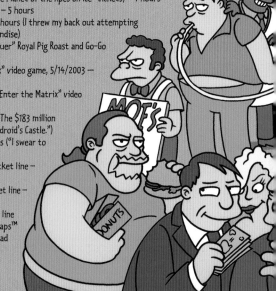

FOOLPROOF TIPS ON HOW TO ENDURE LONG LINES OF HUMAN FLOTSAM AND JETSAM

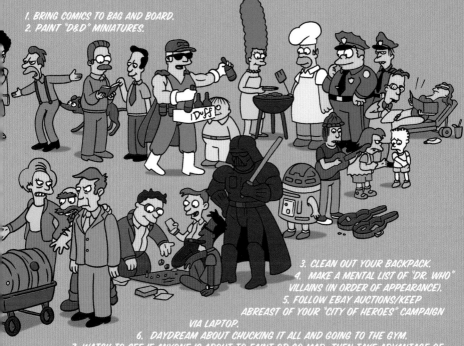

1. BRING COMICS TO BAG AND BOARD.
2. PAINT "D&D" MINIATURES.

3. CLEAN OUT YOUR BACKPACK.
4. MAKE A MENTAL LIST OF "DR. WHO" VILLAINS (IN ORDER OF APPEARANCE).
5. FOLLOW EBAY AUCTIONS/KEEP ABREAST OF YOUR "CITY OF HEROES" CAMPAIGN VIA LAPTOP.
6. DAYDREAM ABOUT CHUCKING IT ALL AND GOING TO THE GYM.
7. WATCH TO SEE IF ANYONE IS ABOUT TO FAINT OR GO MAD, THEN TAKE ADVANTAGE OF THEIR PLACE IN LINE WHEN CHAOS ENSUES.
8. FANTASY FILK SINGING CAN PROVIDE COUNTLESS HOURS OF FUN. OF COURSE, IT CAN ALSO GET ONE PUNCHED IN THE FACE.
9. WRITE HATE LETTERS TO THOSE YOU HATE IN THE ENTERTAINMENT INDUSTRY.
10. SHOUT, "HEY, IS THAT BUFFY THE VAMPIRE SLAYER'S ALYSON HANNIGAN?" WHEN THE RUBES RUSH OFF IN A MAD FAN-PANIC, STEP TO THE FRONT OF THE LINE.
11. CALL YOURSELF ON YOUR CELL PHONE SO THAT EVERYONE WITHIN EARSHOT WILL BE IMPRESSED WITH YOUR "STAR WARS" RING TONES.
12. IF ALL ELSE FAILS, THERE'S ALWAYS "STAR TREK" MAD LIBS.

THE EIGHTEEN TYPES OF MOVIEGOERS

1. MR. SNOOZY
2. THE HOOLIGANS
3. THE UBIQUITOUS OLD FARTS WHO ALWAYS PICK THE WRONG MOVIE
4. THE LATECOMER
5. THE HECKLER
6. TALK TO THE SCREEN GUY
7. THE WAILING BABY
8. THE OBSTRUCTIONIST
9. THE TRUE CINEMAPHILE
10. THE SCREAM QUEEN
11. MR. JADED
12. THE LIBRARIAN
13. THE PHONE PHILISTINE
14. SNEAKY PETE
15. THE QUIZZLER
16. MR. KNOW-IT-ALL WHO THINKS READING "ENTERTAINMENT WEEKLY" MAKES HIM A FILM EXPERT
17. THE "GET A ROOM" COUPLE
18. THE BRIDES OF CRANKENSTEIN

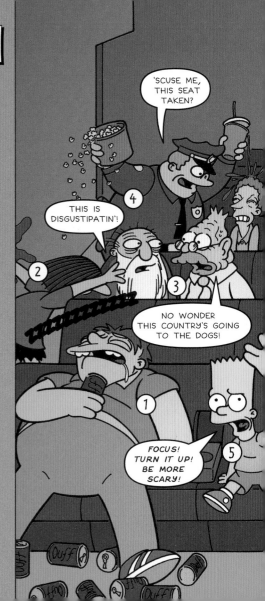

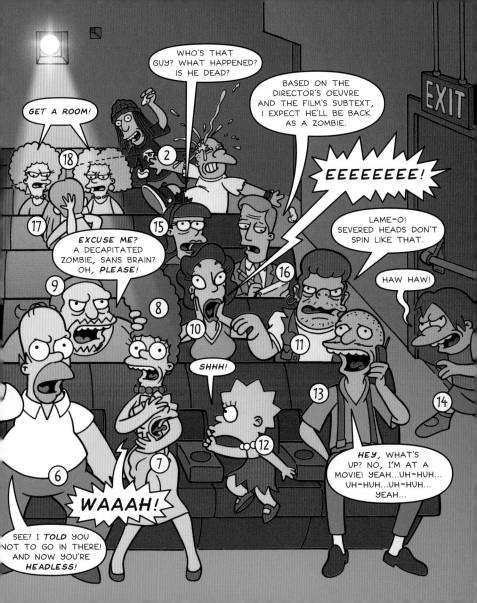

AS BOTH POP CULTURE CONNOISSEUR AND PURVEYOR, I OFTEN RUB ELBOWS WITH THE LEADING LIGHTS OF FILM, TELEVISION, GRAPHIC LITERATURE, AND, *OF COURSE*, HORROR MOVIE MAKEUP. HERE'S BUT A SAMPLING OF THE INDUSTRY ICONS I HAVE MET. DON'T *YOU* WISH YOU WERE *ME*?

CBG'S BRUSHES WITH GREATNESS

At SFFHCBAA CON '87, genius author and raconteur Harlan Ellison rudely insulted me after I asked him about his "Voyage to the Bottom of the Sea" script, then threw a seltzer in my face. I fished the bottle out of the garbage and recently sold it on eBay for $15. Methinks the last laugh is on Mr. Ellison.

Here I am getting Buddy Hodges, the original Fallout Boy, a double Irish coffee at the last Fantasy Con in 1999. He tips quite nicely, by the way.

I was hit by a guy dressed as a Jawa who hit a guy dressed as a Tusken Raider who punched Mark Hamill (dressed as Luke Skywalker) at the infamous Bi-Mon Sci-Fi Con riot.

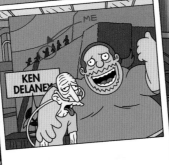

Rob Van Dam and I met at an ECW house show. True, we didn't have much time to talk, but we definitely connected.

That's me with Ken Delaney, who so memorably portrayed the third Klingon on the left in the classic "Star Trek" episode "The Day of the Dove."

Stan Lee once spent a good long while in my shop. I haven't washed it since. 'Nuff said.

- Gore makeup expert Tom Savini made a disastrous appearance at my shop, resulting in my first (and worst ever) heart attack.
- I caught a glimpse of William Shatner outside a hotel in New York City. Then my stupid binoculars fogged up, and after I wiped them clean, he was gone.
- One evening I called Adam West and asked him to do an appearance at my shop. He hung up on me, but not before we exchanged some choice words. An incredible moment I will never forget. Too bad he's since changed his number.
- I once happened to be behind Lynda Carter's home, by her garbage cans. She came out with a Hefty bag. Our eyes locked. It was magic. Then came the police, and, well, my cousin who's a lawyer says I can't say any more about it.
- I met a guy who I thought was Sean Connery. Only it wasn't him. Still, it was really close.
- I stumped comic book superstars Mark Waid and Kurt Busiek on a Silver Age trivia panel at the San Diego Comic-Con in 1990. I bet they're still burning.
- Lucy Lawless. I've met her on several glorious occasions. And let me tell you, like her character Xena, she can hit quite hard.
- Back in the '80s, I traded bootleg "H.R. Pufnstuf" tapes with the guy who played Boomer on "Battlestar Galactica."
- I met the guy who ruled the panel borders and erased the pencil lines on the first issue of "Radioactive Man" where Satyr Master appeared in his third costume (#76). I thought I was going to have an aneurysm; I was in such abject awe.
- I spoke to Bruce ("Evil Dead") Campbell online once. At least he signed his chat room messages "Bruce Campbell." He typed "kewl" a lot. Still, I'm pretty sure it was indeed he.

COMIC BOOK GUY'S DREAM HOUSE

1. Moat filled with smart cybersharks.
2. The Crypt of Toys.
3. X-Men Danger Room (only not so dangerous).
4. Laundry-bot.
5. Home theater with every movie ever made.
6. Life-size Rock-'Em Sock-'Em Robots.
7. Climate-controlled Vault of Comics.
8. Death-Star-like air defenses.
9. Tardis-like Panic Room.
10. Sliding "Star Trek" doors throughout.
11. The Captain's Bridge (replete with ensigns).
12. Working Bat-signal.
13. Bedroom of Justice.
14. Slave girl Princess Leia maid.
15. Lynda Carter as Wonder Woman statue.
16. Real Lynda Carter.
17. Water bed filled with The Blob.
18. Mylar snug sheets and pillowcases.
19. "Comic Book Price Guide" ticker tape machine.
20. Conveyor belt stairs.
21. Extra-wide Bat-pole, with training stirrups.
22. Chocolate Factory with Oompa Loompa servants.
23. Kid Comic Book Guy sidekick/whipping boy.
24. R2-D2 milkshake bartender.
25. Lurch butler.
26. Stargate entrance.
27. Dungeon basement (parents' quarters).
28. Batcave.
29. Friends.

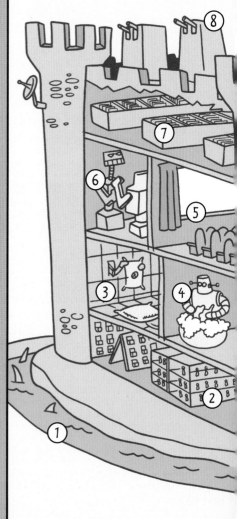

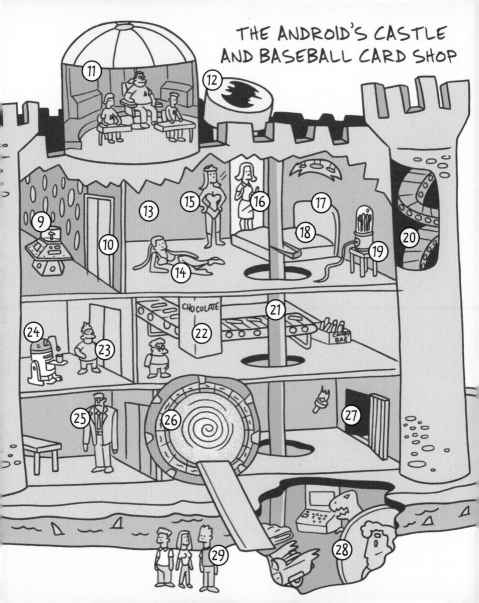

THE ANDROID'S CASTLE
AND BASEBALL CARD SHOP

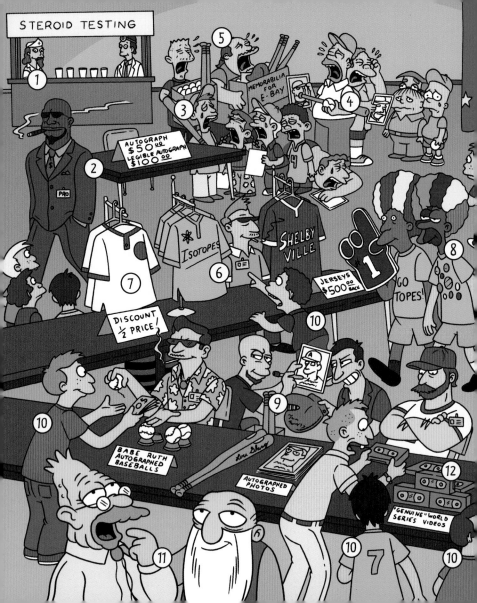

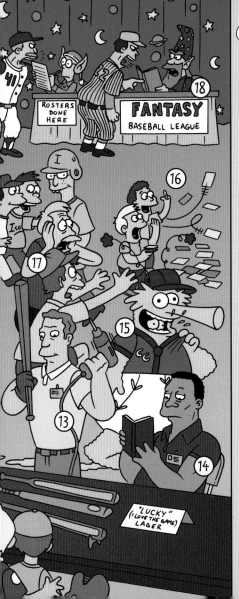

CBG PLACES TO BE

BASEBALL CARD CONVENTION

1. Steroid-testing booth.
2. Millionaire pro leaving autograph table two hours early.
3. Heartbroken kids going home without an autograph.
4. Heartbroken dads going home without an autograph.
5. Heartbroken speculators going home without an autograph to resell on eBay.
6. Overpriced team and player jerseys.
7. Discounted jerseys (indicted/convicted players).
8. Scary fans.
9. Dealers forging signatures on sports memorabilia.
10. Dupe shelling out beaucoup bucks for forgeries.
11. Old-timers waxing nostalgic about Brooklyn Dodgers players that never existed.
12. Bootleg tapes of playoff games, World Series games, and bench-clearing brawls.
13. Bat-corking demonstration.
14. Lonely pro player actually in it for the love of the game.
15. Local hire in mascot suit (stewing in his own sweat and urine).
16. Kids flipping baseball cards.
17. Adults flipping out that kids are "ruining valuable collectibles."
18. Fantasy Baseball League booth.

REVENGE OF

ACTUAL DATE WITH AN ACTUAL LIVING WOMAN

ROAD TRIPS

FUNERALS

WEDDINGS/BAR MITZVAHS

THE T-SHIRT

WHO'S YOUR DADDY?

STAR WARS CONVENTION

I CAN'T HANDLE THE TRUTH!

COURT HEARINGS

c:/dos
c:dos/run
run/dos/run

MENSA MEETINGS

DON'T BLAME ME, I VOTED FOR FRODO!

ELECTION DAY

COMIC BOOK GUY'S GUIDE TO THE INTERNET

IMPORTANT NOTE!!!
Before you sign on to the Net you will need: malted milk balls, chocolate frosting, and a super-jumbo Squishee.

AH, *THE INTERNET*: THE WILD, LAWLESS LAND WHERE NERDS PREY UPON THE WEAK, JUST AS THE MORLOCKS WILL SOMEDAY PREY UPON THE ELOI.

CYBERSPACE IS RICH IN REWARDS FOR THOSE WHO ARE PREPARED. COVER GALLERIES, BOOTLEG FILES, ENTERTAINMENT INDUSTRY GOSSIP, AND SMUTTY IMAGES OF JESSICA RABBIT AWAIT, IF YOU KNOW WHAT YOU ARE DOING. IDENTITY THEFT, COMPUTER VIRUSES, BEATINGS, ARREST, AND IMPRISONMENT AWAIT YOU, IF YOU DO NOT.

TOP-TEN MOST IMPORTANT WEB SITES
This is where you will spend 90% of your time online.
Bookmark these sites immediately.

1. Marvel Comics home page.
 www.marvelcomics.com
2. DC Comics home page.
 www.dccomics.com
3. The Grand Comic Book Database
 www.comics.org
4. Sansabelt expanding slacks online catalogue
 www.sansabelt.com/actionapparel
5. Klingon/English Translation Dictionary
 www.kli.org/takingittooseriously
6. Cyberworld Virtual Simu-Date Online Experience
 **www.cybertown.com/dating/
 simu-date/desperate**
7. *Space Mutants* fan appreciation site (of *Space Mutants 1, 2, 3,* and *5,* but certainly NOT *4.*
 www.spacemutantsrule.com/4sucks
8. Shakes and pie. Recipes for the heart-challenged gourmand:
 www.unhealthyheart.com/recipes
9. Twist Ties online. A living history of this fascinating fastener.
 www.twistmaniac.com
10. Best Web site ever! Gonzo films, illegal downloads, blogs.
 www.dorks-gone-wild.com

TOP-FIVE "ADULT" WEB SITES

1. Saucy images of Jessica Rabbit: **www.toonsmut.org/
 jessica/getsuedbyDisney**
2. European Comics Online: Barbarella, Cicciolina, Druuna, the adventures of women with names that end in a vowel.
 www.eurotrash.com/comics
3. Slash Fiction Zone: An archive of fictional adventures starring the charismatic Guns n' Roses guitarist, Slash.
 www.slashficzone.com/stories
4. T-shirt Palace: People who will print anything on a T-shirt. I mean *ANYTHING!*
 **www.tshirtsrus.com/
 anything-I-mean-anything/html**
5. Krusty's Adult Chat Palace: Where fans of clown-related pornography can meet and discuss.
 www.krustyschatpalace.com/adult/sexyseltzer

COLLECTING ONLINE

There are many Web sites for people to auction off the collectibles they have found in their attic. I encourage people to do so, and often. May I recommend eBuy, Collector's Attic, and the used items section of Amazonian.com. On the other hand, I advise that you do NOT use these sites to bid on items, for it drives up the price for authorized collectors, AND it is fraught with danger. Here is what the uninitiated might expect when bidding on or ordering items from online memorabilia dealers

- **EBUY.com:** Delivery man will bring you half of your order and will hit you.
- **AMAZONIAN.com:** Will steal your credit card number and purchase a Venezuelan timeshare.
- **SPRAWLMART.com:** The company requires YOU to pick up purchases at their store. Stores are always in the most dangerous part of town.
- **COLLECTORSATTIC.com:** Will steal your credit card number and purchase a fleet of mid-size sedans, which will be stripped and shipped overseas to Venezuela.
- **SPENDZILLA.com:** Product arrives in a box with a notable bend in it.
- **FRODOSOFSHELBYVILLE.com:** Arrogant foreigners take your online order, then they come to your house and set it on fire.
- **ANDROIDSDUNGEON.com:** The best site for online collecting. Promptness, courtesy, and reasonable prices for your hobby needs. HIGHLY recommended.

COMMUNICATING

Part of the appeal of chat rooms and e-mail is the chance to meet people, discuss things, and start rumors, without having to wear pants. But there are phrases and words that you must first learn. No one types the phrase "I'll be right back" when BRB will do. Here's a handy chart of easily recognized CIA (Common Internet Abbreviations):

LOL: Laughing Out Loud
LPH: Living in Parents' House
LPB: Living in Parents' Basement.
LPGHFWD: Living in Parents' Garage, Had Fight With Dad
MTSM: Marvel Tales featuring Spider-Man
MSM: Magnificent Shatner Moment
OMG: Oh My God
PPSS: Peter Parker, the Spectacular Spider-Man
ROFL: Rolling On Floor Laughing
TSS: The Spectacular Spider-Man (dropped "Peter Parker" from title with #96)
TWOH: Typing With One Hand (due to eating snacks or a disability)
WEE: Worst Episode Ever

G: Grins
YR: Yeah, RIGHT (must be typed ASAP)
ASAP: As Sarcastic As Possible
BRB: Be Right Back
BMP: Burst My Pants
COBLAR: Crawling On Belly Like A Reptile
FYI: For Your Information
IIRC: If I Recall Correctly
IM: Instant Message
IMO: In My Opinion
IMYO: I Mock Your Opinion
IWMYO: Idiots Would Mock Your Opinion
IRL: In Real Life
CTFCP: Can't Type – Fingers Covered in Pudding
CTFCPCG: Can't Type – Fingers Covered in Pork Chop Grease
CTFCGP: Can't Type – Facing Constant Gastric Pain.

ADULT CHAT ROOMS

have their own special phrases — I have dropped into the Princess Leia's Brass Bikini Slave Auction room at Jabba'sChatZone.com from time to time (screen name I'mHereToRescueYou042), so trust me, I am in the KNOW.

THE MOST COMMONLY USED ABBREVIATIONS IN ADULT CHAT ROOMS:

AWE: A Woman Entered!

BEG: Big Evil Grin

CRY: "(C) Real You?" (or "May I see a photo of you?")

PLEAD: Pretty Lady Encountering Anyone Datable?

WHINE: What's Happenin'? Interested in New Experiences?

LIMP: Look In My Profile

IOCKWH: If Only Captain Kirk Was Here

FLAME WARS

"Flaming" is the Internet term for arguing with people who are beneath you. Named after the Human Torch, whose fiery scraps with Ben "The Thing" Grimm set the standard for a generation, flame wars happen when people disagree in a chat room, bulletin board, or newsgroup, and one of the parties is a moronic troll.

HOW TO START A FLAME WAR

1) Find a chat room, bulletin board, or newsgroup that interests you.
2) Type something controversial.
3) Wait.
4) Someone will call you a moronic troll.
5) You, in turn, call them one.
6) Repeat.

HERE ARE MY 18 FAVORITE WORDS TO USE IN A FLAME WAR (IN ALPHABETICAL ORDER):

BEFOUL	MALIGNANT	SCOUNDREL
CONTEMPTIBLE	MORON	SEBACEOUS CYST
FRENCH	MORON-APALOOZA	SWINE
GULLIBLE	MORONIC	TROLL
IGNORAMUS	PALTRY	UNCULTURED
ILLITERATE	PUSTULE	"VOYAGER" FAN

Some of these words and phrases cross a line, admittedly, but you have to "BRING IT," or you will not be respected in the dog-eat-dog world of flaming.

INTERNET RUMORS I HAVE STARTED

- Sewers flood during commercials on "Matlock" broadcasts when old people flush simultaneously.
- Devil babies roam the forests to the north of the city.
- "Styles" of the California Raisins left the band to form Prince and The Revolution.
- Hair weaves from overseas are infested with cobra eggs.
- Bruce Willis has a vestigial tail.
- Duff Dark is "flavored" by employees who swim naked in the brew vat.
- "The Twilight Zone" never had original airings, but BEGAN its existence as a rerun.
- If you find a fried rat in your Krusty brand Ribwich, you get a free franchise, which is why they stopped offering that meal. Oh, yes, and if you cut a Krustyburger in two, it will crawl in opposite directions because of all the live worms added into the mix to meet protein standards.

- Teleportation experiments were tested in Springfield in the '50s. The exact location cannot be confirmed, because it was teleported away.
- An underground complex in Springfield houses a "top secret" strike force of antimonster troops who stand ready to face Godzilla, Mothra, and the army of devil babies to the north of the city.

START YOUR OWN RUMORS ON THE NET AND SEE IF THEY COME BACK TO YOU! IT'S FUN AND RARELY RESULTS IN ARREST OR LAWSUITS!

A home page is the ultimate personal expression of self. It is a place to gather interesting or clever images and files from other web sites, and show them to the world, so that visitors to your site associate the cleverness with you.

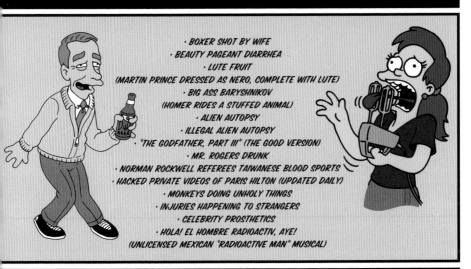

- *BOXER SHOT BY WIFE*
- *BEAUTY PAGEANT DIARRHEA*
- *LUTE FRUIT*
- *(MARTIN PRINCE DRESSED AS NERO, COMPLETE WITH LUTE)*
- *BIG ASS BARYSHNIKOV*
- *(HOMER RIDES A STUFFED ANIMAL)*
- *ALIEN AUTOPSY*
- *ILLEGAL ALIEN AUTOPSY*
- *"THE GODFATHER, PART III" (THE GOOD VERSION)*
- *MR. ROGERS DRUNK*
- *NORMAN ROCKWELL REFEREES TAIWANESE BLOOD SPORTS*
- *HACKED PRIVATE VIDEOS OF PARIS HILTON (UPDATED DAILY)*
- *MONKEYS DOING UNHOLY THINGS*
- *INJURIES HAPPENING TO STRANGERS*
- *CELEBRITY PROSTHETICS*
- *HOLA! EL HOMBRE RADIOACTIV, AYE!*
- *(UNLICENSED MEXICAN "RADIOACTIVE MAN" MUSICAL)*

FAN FIC (short for fan fiction):

JUST BECAUSE THE ILLITERATE MANATEES THAT RUN THE MAJOR MEDIA OUTLETS DO NOT RECOGNIZE MY BRILLIANCE, DOES NOT MEAN THAT WEB SURFERS SHOULD BE DENIED MY TALENT. CLICK BELOW TO READ UNOFFICIAL SCRIPTS FOR TV EPISODES YOU'LL NEVER SEE.

WONDER WOMAN AND THE LEATHER-CLAD CREATURES OF MARS
THE AMAZONIAN MAID TEAMS UP WITH A FAT, BALDING FELLOW FROM "MAN'S WORLD" AND FINDS NEW LUST GROWING WITHIN HER... CLICK HERE FOR MORE

XENA RIDES AGAIN
THE WARRIOR PRINCESS IS SAVED FROM DEATH BY A CHARMING PONYTAILED MAN WITH A BIG APPETITE, AND SHE INSTANTLY FLINGS HERSELF UPON HIM... CLICK HERE FOR MORE

STAR TREK: THE LOST VOYAGE
KIRK AND SPOCK ARE RESCUED FROM A LONELY ASTEROID BY A STOUT, BEARDED SPACE CAPTAIN FROM ANOTHER GALAXY WHO STARES AWKWARDLY AT THE FLOOR WHEN THEY OFFER TO THANK HIM... CLICK HERE FOR MORE

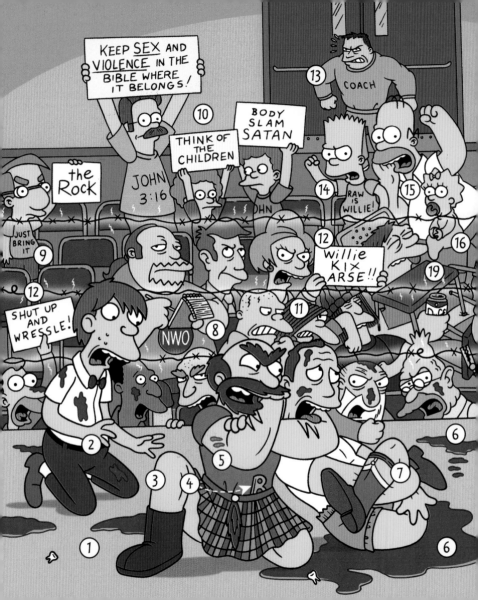

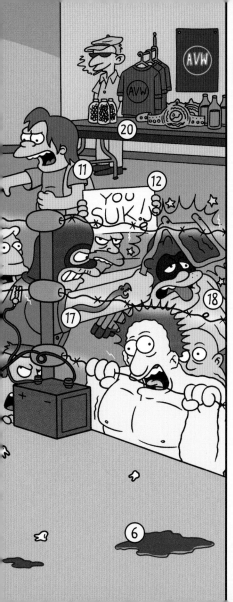

CBG PLACES TO BE
INDY PRO WRESTLING EVENT

1) Tag-team, no-DQ, flaming barbed wire, death match in progress
2) Referee (day job: shopping cart herder at Piggly Wiggly)
3) Local wrestling legend
4) Illegal foreign object
5) Fake blood
6) Real blood
7) Has-been ex-WWE jobber contemplating career change and/or suicide
8) Humorless "smart mark" taking notes for his wrestling Web site
9) Unhappy kid who thought The Rock would be here
10) Locals protesting against wrestling supposedly corrupting the youth of America
11) Corrupted youth of America
12) Misspelled signs
13) Jealous high school wrestling coach
14) "You suck" chant instigator
15) Fan who thinks it's real
16) Small child too young to be there
17) Masked wrestler (wanted by police)
18) Wrestler who has taken too many chair shots to the head
19) Fan who's taken too many chair shots to the head
20) Merchandise table

NOT PICTURED:

21) Promoter running off with gate proceeds
22) Wrestler being taken to emergency room
23) Fan who hit him being taken to emergency room

A GUIDE TO AD

EMPEROR DALEK

FALLOUT BOY

RAY BRADBURY

SPIDER-MAN

DICK TRACY

TRON

AQUAMAN

RED POWER RANGE

ULT UNDEROOS

BATMAN

CURIOUS GEORGE

HE-MAN

MACHO MAN
RANDY SAVAGE

CHARLIE BROWN

MAX

THE THING

CBG PLACES TO BE
YARD SALE

1. Scary guy sniffing around for war memorabilia.
2. Irritating "Antiques Roadshow" fan with antiques price guide.
3. The massive pile of used-only-once products from Ronco.
4. First schmuck of the day to ask, "How much for the yard?"
5. Lemonade stand.
6. Mystery VHS tapes. ("MacGyver"? "Knight Rider"? "Airwolf"? You pays your money and you takes your chances.)
7. Cracked bowling ball with five finger holes.
8. Dirty, scratched vinyl records in dirty, stolen milk crates.
9. The mighty hunter (looking for $5 items to bargain down to $1 and sell in his shop for $20).
10. Irritating hipster with parents' money.
11. Borrowed, unreturned neighbor's items on sale cheap.
12. The big box of obsolete technology (Betamax, typewriter, Super-8 camera, flash cubes, record player, 25-function calculator, AM headphones, 8-track, cassette player, Segway).
13. The small box of dead fads (Pet Rock, Chia pet, Tamagotchi, Troll dolls, mood rings, love beads, black light posters).
14. Beer can collector.
15. The "Usual Suspects" book pile ("Fear of Flying"; "Oliver's Story"; "Jonathan Livingston Seagull"; "I'm OK, You're OK"; "Guinness Book of World Records 1987"; "Ziggy" collections).
16. Case of "I (Heart) Poochie" promo T-shirts.
17. Musty trunk of old magazines (including "Creem," "Cracked," "Pro Wrestling Illustrated," "Dynamite").
18. Old clothes from dead relatives.
19. Wedding presents old enough to finally dump.

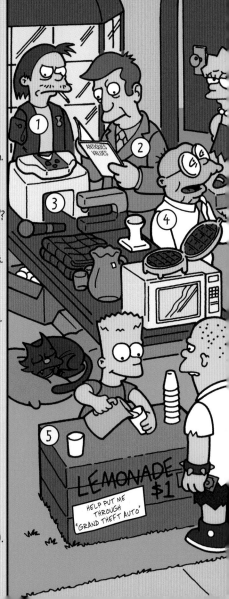

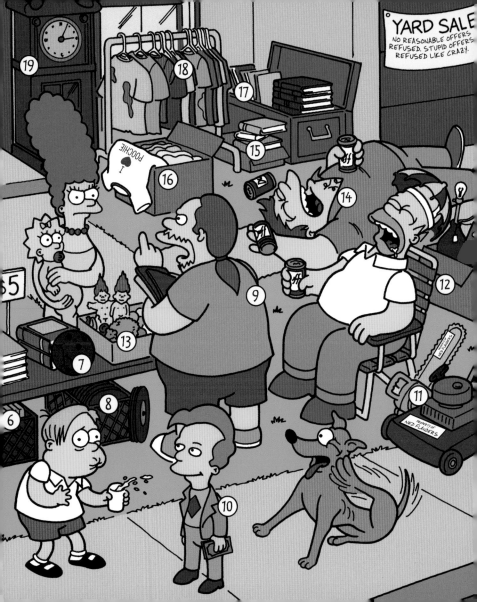

YARD SALE
NO REASONABLE OFFERS
REFUSED. STUPID OFFERS
REFUSED LIKE CRAZY.

ver gone to the local toy store in search of an action figure, only to find the shelves as bare as Linnea Quigley in *Return of the Living Dead*? That's because big-game toy hunters like myself got there first! Read on, MacDuff, and learn how to amass a collection so large you'll have to pay to put most of it in storage!

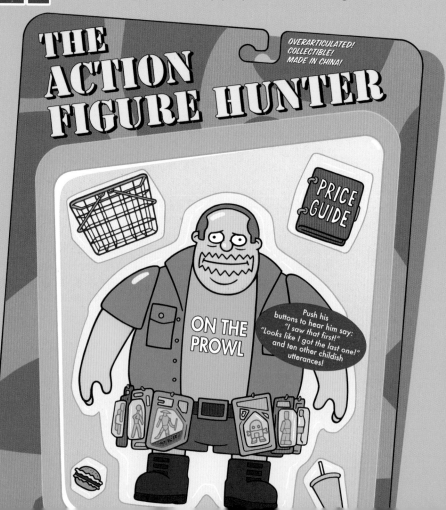

OVERARTICULATED!
COLLECTIBLE!
MADE IN CHINA!

THE ACTION FIGURE HUNTER

PRICE GUIDE

ON THE PROWL

Push his buttons to hear him say: "I saw that first!" "Looks like I got the last one!" and ten other childish utterances!

HERE'S HOW YOU TOO CAN AMASS A COLLECTION WORTHY OF THE TOY GODS

SCOPING OUT THE TERRITORY

Stay on top of toy releases via trade magazines and the Internet.

Memorize local toy store hours.

Learn the shipping days at various stores. Hit them early, fast, and often.

Make friends with store clerks/stockroom boys. These are your all-important inside men. Get in their good graces, and they'll "accidentally" forget to put short-packed action figures out on the shelves and hold these desirable items for you.

No matter how badly you want to insult these morons, belay that impulse. Don't endanger your contacts. (Unless they're screwing you.)

STALKING THE AISLES

Always use a shopping cart. No matter how big you are, two arms are never enough to carry a solid haul.

If other collectors are present, there's no time for cherry-picking. Toss every figure you can grab into your cart, dash off to the baby supply aisle, and sort your pile free from prying geek eyes.

If you're strapped for cash or need to get around store limits on items, hide figures in the store and pick them up later. Good hiding places include: overhead overstock bins, behind slow-selling merchandise, the stuffed animal aisle, and the girly-girl aisles that no collector would be caught terminated in.

Check the store for figures that may have been left in other aisles by stupid kids, sloppy clerks, and other collectors hiding booty.

Buy five of every figure. One to display, one for a backup, one for customizing, one to trade, and one to put away as an investment.

If you see a kid holding that action figure you need, take it. No one would ever believe you took toys from a baby. (Just watch for parents.)

THE ELUSIVE KID'S MEAL TOY

Scout fast food establishments for info on when new toys will be available.

Hit up every location in the area and buy/eat multiple meals.

Ask if you can buy a specific toy your "nephew" has been crying for.

Don't forget the rare under-age 3 toys offered only upon request. These are different sculpts and cannot be overlooked by the adult collector!

Kids often leave their toys on their trays while playing in the restaurant ball pit/jungle gym. Need I say more?

LIMITED EDITION COMIC SHOP–ONLY ACTION FIGURES

I order them for the store and keep them. What my customers don't get won't hurt them.

CBG'S GUIDE TO KEEPING AND

1. Maintain a climate-controlled safe room with 50% humidity, no sunlight, and no parents, dirty children, or nonbelievers allowed.
2. Store comics in acid-free comic boxes in alphabetical order, broken down by category, publisher, hot scantily clad babe quotient, cool monster quotient, etc.
3. Using type D Mylar comic sleeves and acid-free backing boards will ensure that your comics are kept safe from dirt, dust, liquids, McFlurry, grease, spores, mollusks, and enjoyment.
4. **DANGER, WILL ROBINSON!!!** Always keep tape completely away when inserting a comic into a bag!!!
5. A professional forensics kit can come in handy when examining old comics and toys for damage, paint wear, and other grading defects.
6. Cotton gloves are a must. I also recommend a full biohazard suit for maximum protection from the inevitable filth of your own being.
7. Keep records of your collection on paper and on computer. Update them weekly and store copies in a safe deposit box at a trustworthy bank.

8. Costumes and movie props are best displayed on dress mannequins to show off their fine craftsmanship.
9. Peg and rack systems are ideal for carded action figures. They can easily be obtained, a piece at a time, from large, unsuspecting department stores.
10. Glass cases are perfect for statues, toys, and other collectibles such as my collection of Jack Kirby cigar butts from the '70s.
11. A fireproof safe is the place for your most valuable back issues, rare first editions, unsent love letters, and various precious meltables.

STORING YOUR COLLECTION

2. Framing original comic book art is always classy.

3. Ordinary file cabinets are fine for newspaper clippings, obituaries, shut-off notices, death threats, etc. This is part of my "injury-to-eye" motif collection.

4. Substitute Silly Putty for expensive museum wax to hold down items during earthquakes or other debacles.

5. You may wish to erect a "special handling" area for your most rare and valuable collectibles.

6. Where I store my prize bootlegs is none of your beeswax.

7. **WARNING! TAKE BREAKS FROM BAGGING COMICS EVERY FEW HOURS OR RISK DEVELOPING THE FOLLOWING COLLECTOR'S CALAMITIES!!!**

- Scotch tape fingers
- Collector's knees
- B.E.G.
- Rump rash
- Negative zone-out (mild psychosis brought on from reading instead of bagging comics)
- Asphyxiation from mixing cleaning supplies

THE AMAZING WORLD OF COLLECTIBLE FOOD

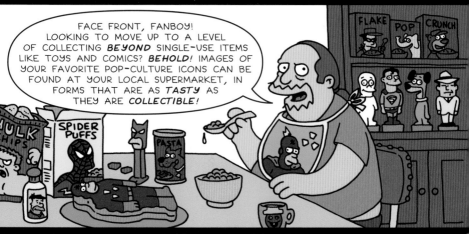

FACE FRONT, FANBOY! LOOKING TO MOVE UP TO A LEVEL OF COLLECTING **BEYOND** SINGLE-USE ITEMS LIKE TOYS AND COMICS? **BEHOLD!** IMAGES OF YOUR FAVORITE POP-CULTURE ICONS CAN BE FOUND AT YOUR LOCAL SUPERMARKET, IN FORMS THAT ARE AS **TASTY** AS THEY ARE **COLLECTIBLE!**

IS FOOD COLLECTIBLE JUST BECAUSE IT'S SHAPED LIKE AN ACTION HERO?

HEAVENS, NO!

Fig. 1) Potato chip shaped like Krusty. **Valueless.**

Fig. 2) Krusty Brand™ potato flavored soy-paste "chipette." **WORTH: $.02-$.09** (depending on age and grade).

Fig. 3) Homemade Radioactive Man cake. I'm sure your children enjoyed the EFFORT. **Valueless.**

Fig. 4) Krusty Brand™ pasta-flavored soy-paste-a-ghetti. **WORTH: $1.25** (mint in can).

A good rule of thumb: NATURAL edibles CANNOT be as collectible as corporate-approved OFFICIAL food-based products.

TO EAT OR NOT TO EAT? THAT IS THE QUESTION.

This query has plagued the character food collector for years. With modern methods most foods can be preserved indefinitely, so nothing must be eaten. An easy, if expensive, solution is to buy multiples.

However, if the food itself is not shaped like anything, and is merely inside a collectible container, such as this jar of Captain Squid Peanut Butter, you may indulge in a feast.

Chocolate is difficult to preserve and should only be eaten if the shape is a lesser character. This milk chocolate Weasel Woman Easter figure is permissible to eat, but you should hold on to a marzipan Wolverine.

FREE RANGE FOOD

Han Solo Frozen Carbonite Beef Clumps.

Grade: Edible and in Near Mint Condition.

Grade: Inedible and Stinky to Very Stinky. Some Dark Lord left the freezer door open.

GRADING YOUR COLLECTIBLES

Like any collectible, food deserves to be graded by condition, if not by odor.

CANNED GOODS
Presented for your inspection: four cans of collectible food in various grades.

GRADE A
Mint in can. (Get it?)

GRADE B
Can dented, label intact.

GRADE C
Dented, label gone. Food intact.

GRADE Z
Can open. Value drops by the minute.

WHAT'S IT WORTH?
Though value can be determined by popularity of character and scarcity of item, most novice collectors ignore the all-important composition factor. Check this handy chart:

SOY **GUMMI** **PRESSED FRUIT JERKY** **CEREAL** **PASTA** **COOKIE/ CRACKER** **CHOCOLATE** **ICE CREAM** **MEAT** **CAVIAR**

WHO WILL WIN THE GREAT CEREAL BOX WARS?
Cereal boxes are highly collectible and have been a great source of gambling-related fun for me, personally.

FANTASY GAMBLING AND FANTASY EATING ARE TWO TREATS THAT GO GREAT TOGETHER!

ONY THE TIGER: Odds **6 to 1.**
Vicious feral predator.

QUAKER GUY: Odds **3 to 1.**
You can't see his hands, so he **may** be packing heat.

COUNT CHOCULA: Odds **3 to 1.**
Monstrous power is easily defeated by Two Scoops of the Raisin Bran Sun.

CAP'N CRUNCH: Odds **3 to 1.**
Armed with a sword and supported by a small crew of scurvy sailors.

TRIX RABBIT: Odds **10 to 1.**
Silly and easily recognized when in stealth mode.

LUCKY THE LEPRECHAUN:
Odds **2 to 1.** Magically pernicious. Favored to win if he can avoid the tiger, the vampire, or the angry Puritan.

TOUCAN SAM: Odds **50 to 1.**
High probability of being eaten by tiger in early rounds.

COCOA PUFFS BIRD: Odds **10 to 1.**
Might surprise. Clearly unafraid of pain.

HERE AT **COCKAMAMIE'S**, YOUR **KITSCH** IS ON **MY LIST**. WE'VE GOT THE COOLEST IN CAMP AND THE CAMPIEST IN COOL. YOU'VE TRIED THE REST, NOW TRY THE **RETRO**-EST. BROWSE THE HOUSE DOWN, BUT REMEMBER, IF YOU BREAK IT, YOU FIX IT. AT HOME. AFTER YOU **BOUGHT** IT.

Cool, Kitschy Collectibles

EASTER ISLAND HEAD ICE BUCKET
TIKI IS HOT, BUT RAPA NUI IS ICE COLD!

CERAMIC PRAYING PLAYBOY BUNNY
DEAR LORD, PLEASE DON'T LET ME SPILL THAT OUT-OF-TOWN BUSINESSMAN'S DRINK ORDER!

"NO PEST STRIP" EARRINGS
WHO NEEDS TO BATHE WHEN YOU'VE GOT THESE BABIES KEEPING FLIES AWAY?!

TED KENNEDY NUTCRACKER
FOR ALL YOUR FILBERT-BUSTING FILIBUSTERS!

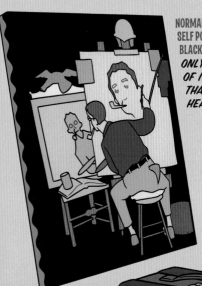

NORMAN ROCKWELL SELF PORTRAIT ON BLACK VELVET
ONLY ONE OF ITS KIND! THANK HEAVENS!

MUSHROOM CLOUD SUN HAT
NOTHING BEATS THE LIVING DAYLIGHTS THAN THE DEAD OF NUCLEAR NIGHT!

"THE MCLAUGHLIN GROUP" LUNCH BOX
HAVE YOUR LUNCH WITH THE BRAINY BUNCH!

KRUSTY THE CLOWN COCKTAIL SHAKER
HEY HEY, KIDS! MAKE THOSE MARTINIS MAMBO!

LIZ TAYLOR WEDDING TOPPER
COMES WITH REPLACEABLE GROOM HEAD!

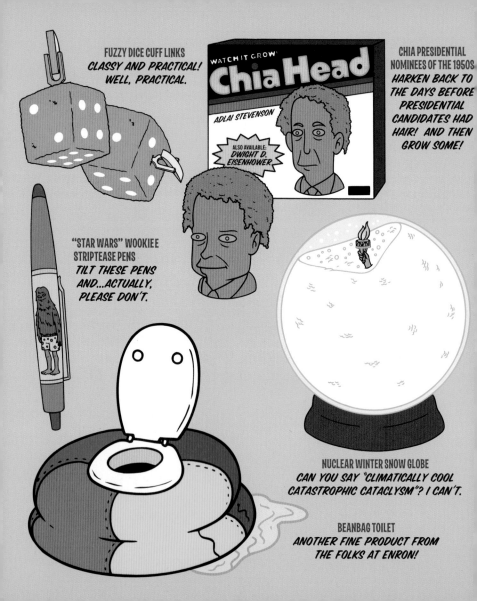

BIG EYE STATE DEPARTMENT PORTRAITS
FOR THE WIDE-EYED INTERNATIONAL DIPLOMAT IN ALL OF US!

FISHNET-CLAD PROSTHETIC LEG
THEY WORK AS LAMPS AND END TABLES. WHY NOT USE ONE AS A LEG?

DEFUNCT DRINKS NESTING DOLLS
MAKES ME THIRSTY FOR A GLASS OF WINK RIGHT NOW!

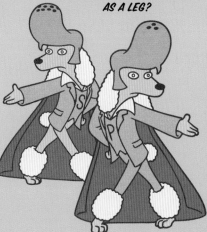

AND FINALLY, THE GREATEST KITSCH GIFT IN HISTORY:
FLAMENCO-DANCING ELVIS-COIFED POODLE SALT & PEPPER SHAKER FRIDGE MAGNETS
GIVEN BY ANDY WARHOL TO JACKIE KENNEDY AT THE 1964 WORLD'S FAIR! I CAN DIE HAPPY.

CBG PLACES TO BE

SCI-FI COMIC BOOK CONVENTION

1. Cute costumed kids.
2. Creepy costumed adults.
3. Surly dealer with worst back issue prices ever.
4. Lawyers looking for bootleg merchandise.
5. Bootleg merchandise.
6. Soap, breath mint, and deodorant concession.
7. Furries—direct from the Ninth Circle of Hell.
8. Backpack mishap resulting in injury.
9. Angry small press cartoonist (at artist table).
10. Famous "S.F." writer attacking fanboy for using the term "sci-fi."
11. Ignored Golden Age comic artist falling into deep sleep/coma.
12. Golden Age comic artist's wife scrounging food.
13. Portfolio reviewer insulting artists.
14. Vampire Dinosaur display (with real blood flow).
15. Repulsed booth babes.
 (Day job: Hooters waitresses.)
16. X-Men/Stormtrooper stare-down.
17. Cosplay girls.
18. Cosplay stalkers.
19. Not pictured—mass repressed sexuality.

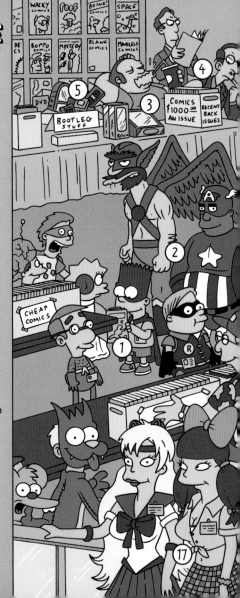

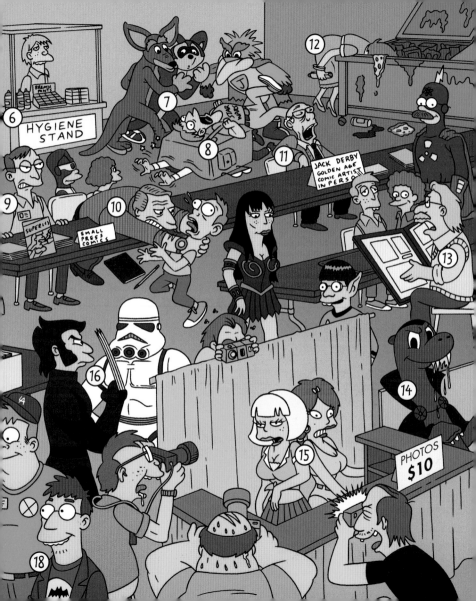

CBG'S COMIC BOOK/SCI-FI CONVENTION SURVIVAL TACTICS

Like Mos Eisley Spaceport, you'll never find a more wretched hive of scum and villainy than at a comic book or science fiction convention. From a battle-scarred veteran of many a convention floor, here are some timeworn tips on getting out alive, intact, and with a backpack full of hot collectibles.

CONVENTION PREPARATION AND ARRIVAL

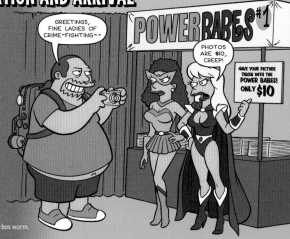

- Make sure your backpack is properly equipped.
- Always get to the convention center as early as possible.
- Once inside, get the program booklet and quickly map out your day down to the minute, so you won't miss a second of the **Silver Age Plot Contrivance Trivia Contest** or the **Voluptuous Vixens of Sci-Fi T&A Q&A**.
- Skip the bathrooms, caramel pretzel kiosk, and the half-naked chippies at the Troma booth (difficult, yes) and head directly to the dealers room.

Remember: the early bird catches the Grade-9 mint-in-box worm.

WORKING THE DEALERS TABLES

- Hit up the Japanese import dealers first. Those Micromen, Gundam Anniversary die-cast kits and Pretty Soldier Sailor Moon schoolgirl uniforms go faster than a bullet train.
- Remember to bargain down everything and everyone. Never pay full price for anything, or you'll be sized up as a sucker and never be given a break at the tables as long as you live.
- Bargaining tip #1: Tell the dealer a guy in aisle 14D has the same comic for $20 less. (Unless, of course, you're in aisle 14D.)
- Bargaining tip #2: Keep the bulk of your cash in your pocket and leave only a few small bills in your wallet. Show the dealer your open wallet and tell him it's all you have left. They love taking your last dollar, even if it means less profit.
- Study the dealers' faces just before the convention closes. Do any of them look suicidal? That's the guy to hit up for bargains.
- Get to know your bootleg video dealer. You'll find the more honorable thieves deal quality illegal material.
- Many dealers don't accept plastic. Bring scads of cash, or better yet, old comics or vintage erotica on VHS for trade.

PERSONAL SURVIVAL

- Your backpack is your body armor. Keep it between you and the crowds at all times.
- Bring sealed food and drink to avoid concession lines and prices. I suggest Mountain Dew and Marshmallow Circus Peanuts for quick energy.
- Know where the convention center exits are in case of an emergency (fire, riot, raid by copyright lawyers, etc).
- Know where the convention bathrooms are in case of a bladder emergency.
- If the bathroom lines are egregiously long, bring a container and head for the curtains behind the signing booths.

INTERACTING WITH OTHER LIFE-FORMS

- It is considered bad form to address a Klingon in English.
- Avoid stepping on con-goers capes, robes, Gorn's tails, etc.
- Steer clear of Stormtroopers. Those goose-stepping simpletons can never see where they're going and clog up the aisles.
- Check anyone dressed as Catwoman for an Adam's apple so you'll know how to address them.
- Always smile at the ladies.

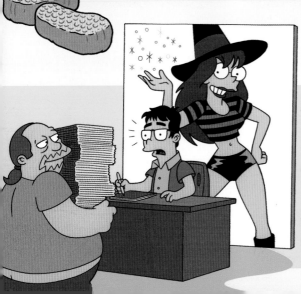

PANELS AND SIGNINGS

- Bring as many comic books to get signed as you can carry. Comic pros are grateful for the opportunity to show their thanks by signing a few hundred comics for their supporters.
- Make sure you always have a front row seat at overcrowded panels by bringing your own folding chair. No one will ever be the wiser!
- Keep a volunteer shirt underneath your clothes or costume. This allows easy access to events, signings, and volunteer-only meals.

THE T-SHIRT W

BAGGING COMICS

ROLE-PLAYING

RETURNING BOTTLES TO THE RECYCLING CENTER

RENEWING DRIVER'S LICENSE

ONLINE DATE, HOPEFULLY WITH AN ACTUAL LIVING WOMAN

ARCADE TRIPS

NEARLY LOSING VIRGINITY

LAUNDRY DAY

SECRETS OF THE ESSENTIAL BACKPACK

To the serious collector, a backpack is more than a mere accessory. It is a lifeline, providing nourishment, emergency supplies, body armor, and a sense of one's own identity. Everything needed to survive labyrinthine convention halls, mile-long flea markets, and getting thrown out of the house at two in the morning by your parents. A backpack says you're serious. A backpack says you're ready for anything. A backpack says, "Get the hell out of my way, or face the bulky wrath of my backpack!" And without a doubt, *my* backpack says these things louder and clearer than anyone else's. Take note, Boy Scouts of America — you *wish* you were this prepared!

COMIC SHOPS OF NORTH AMERICA

PASS

YOU SHALL NOT PASS

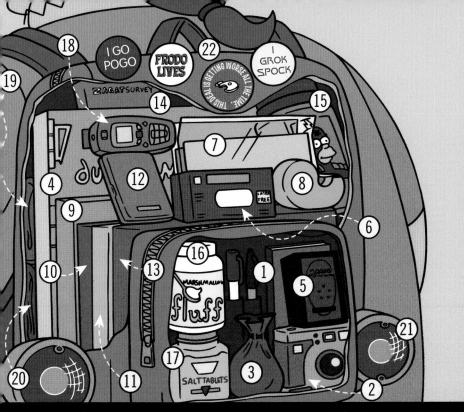

. Autograph book/pens **2.** Digital camera (for confirming celebrity/rare comic sightings) **3.** Skin of role-playing dice ("You ever know when a high-stakes game might break out.") **4.** *D&D Dungeon Master's Guide* ("Not that I haven't committed the rules to memory.") **5.** Magic: the Gathering deck ("A disciplined warrior must always be ready for battle.") **6.** Disposable sanitary gloves (for handling rare comics and collectibles) **7.** Emergency comic bags/boards **8.** Emergency tape dispenser **9.** Comic book price guide ("Not that I haven't committed most of this year's version to memory.") **10.** Baseball card price guide ("Ditto.") **11.** Toy and collectible price guide ("Ditto.") **12.** Calculator **13.** English to Klingon dictionary ("I am in the process of committing this to memory -- or, 'qawHaq,' as my warrior brothers would say.") **14.** Zagat survey of under-$10 cheese steak chains **15.** Thermos of Yoo-hoo ("Elixir of the gods, lukewarm or cold!") **16.** Marshmallow Fluff ("Just a pinch between the cheek and gums keeps you wide awake while going through the quarter bins!") **17.** Salt tablets **18.** Cell phone turned off in 2004 for nonpayment) **19.** Backup T-shirt (armpits prerolled with deodorant) **20.** Backup underwear (in case of Stan Lee or Lynda Carter sighting) **21.** Alarm and warning hazard lights for backing up while wearing backpack **22.** Life-affirming buttons and patches

DO NOT *THINK* YOU ARE GOING TO TOUCH THESE COMIC BOOKS! FOR THEY ARE *EVERYTHING* YOU ARE *NOT*: PULSE-POUNDING, COLORFUL, UNDAMAGED, AND *MINE!*

I HATH TRULY SWORN AN *OATH MOST SACRED* TO PRESERVE AND PROTECT *THESE*, THE EIGHT ALL-TIME UNDISPUTED...

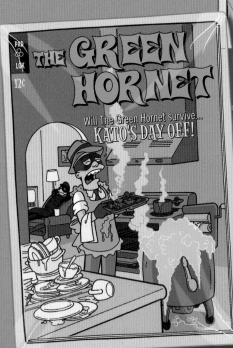

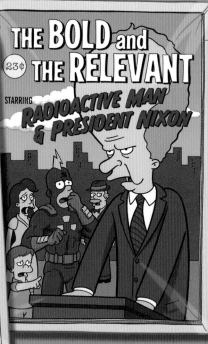

THIS IS WHY *SUPERMAN* HAS *ROBOTS* — NO LABOR LAWS PROTECT *THEM!*

AAAH, RELEVANT COMICS! RIPPED FROM TODAY'S HEADLINES, AND BY "TODAY" I MEAN *1971*, AND BY "HEADLINES" I MEAN THINGS THAT NEVER HAPPENED!

BEST...COMIC BOOKS... EVER!

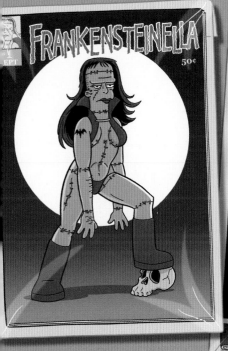

VA-VA-VOOM! I'D LIKE TO SEW *HER* PARTS TOGETHER, IF YOU KNOW WHAT I *MEAN!* WOOF! PANT! NUDGE-NUDGE! ЭSIGH!ϵ I AM SO *LONELY...!*

THE VERY *FIRST* COMICS/VIDEO GAME TIE-IN...AND *STILL* THE *BEST!*

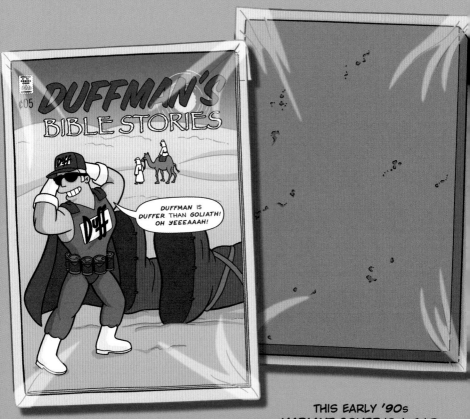

PUBLIC RELATIONS **DAMAGE CONTROL** NEVER LOOKED SO GOOD! **100** ISSUES AND COUNTING!

THIS EARLY '90s **VARIANT COVER** IS A 6 LB. SLAB OF **PEWTER!** IT'S IMPOSSIBLE TO GET TO THE COMIC INSIDE, OR EVEN KNOW WHAT IT IS! BUT WITH PACKAGING THIS **ELEGANT,** IT **MUST** BE A WORK OF UNPARALLELED **GENIUS!**

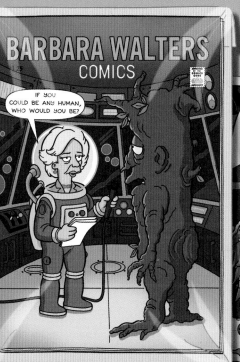

THE BEAUTEOUS *PRESS PRINCESS* INTERVIEWS *ALIENS, DINOSAURS, TALKING PURPLE GORILLAS,* AND *ROBOTS!* THEIR *ANSWERS* WILL *STUN* YOU!

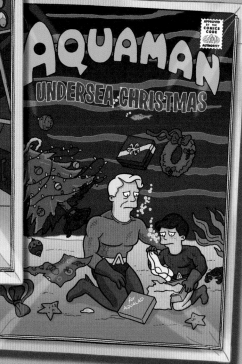

DINNER WAS *UNCOOKABLE,* AND THE *GIFTS* WERE *SOAKED!* THIS ONE *STILL* MAKES ME CRY!

WITH THE HELP OF CUNNING AND STEALTH (TWO BIG WORDS FOR SNEAKINESS), YOUR INTREPID REPORTER (ME) WAS ABLE TO INFILTRATE MY SISTER'S CLOSET AND EXAMINE THE MOTHER LODE (OR IS IT DAUGHTER LODE?) OF CRAPPY GIRL COMICS. COVERS AND COMMENTS APPEAR BELOW. HAVE NO FEAR, I USED THE ALWAYS EMPTY HAZMAT SHOWER IN MY DAD'S OFFICE TO CLEAN OFF ANY RESIDUAL NEWSPRINT OR GIRLIE COOTIES.

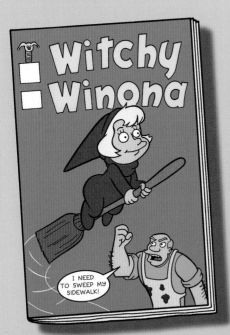

Here's a dropping from the Herve comics stable. It's a rip-off of a spin-off of a take-off of that friendly ghost (who was killed in Vietnam). The scariest thing about this comic is that it exists.

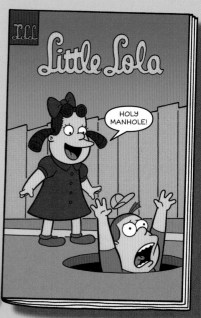

Lola is a dumb girl who likes holes and things that look or act like holes. That's the whole idea. Or should I say "hole" idea? That last line is funnier than the hole comic. So was that one.

BART SIMPSON'S GUIDE TO LISA'S CRAPPY GIRL COMICS

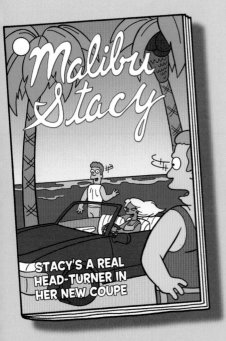

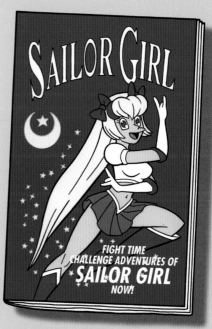

Shameless self-promotion of a doll that fools girls into thinking they should be learning to read comics when they really should be learning to play with dolls.

Cool anime art is wasted in this girl title, which is the biggest mistake Japan made since we bombed them to smithereens at Pearl Harbor.

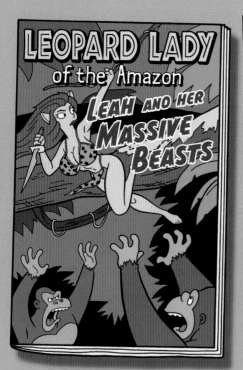

Half girl. Half cat. All boring.
There is something about the cover
that kept me from taking my eyes
off it, but I can't quite put my finger on what it is.

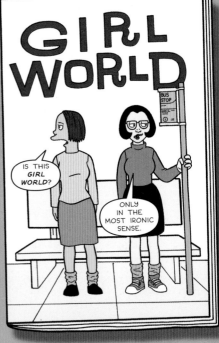

Who reads comics that have words
like **angst** and **self-loathing** and **ovarian** in them?
I wouldn't, even if I knew what
they meant!

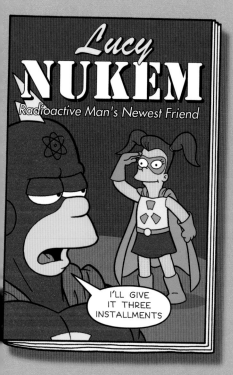

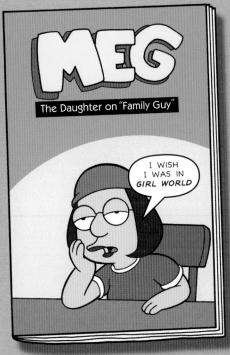

Cheap girl-version of Fallout Boy from "Radioactive Man" comics. No self-respecting kid would read this garbage. But then, that's the definition of a girl comic, isn't it?

Oh please. A comic book based on a character from an animated cartoon? TV should stay on TV, where it can do some good.

THE COMIC BOOK

1. FRODO'S OF SHELBYVILLE.
2. EWOKS. (WORST ANYTHING EVER!)
3. SHOPLIFTERS.
4. COMIC BOOKS NEVER GETTING THE RESPECT THEY DESERVE (ESPECIALLY THE ONES WITH HOT VAMPIRE GIRLS BATTLING HOT NINJA CHICKS).
5. SHAVING.
6. WITLESS PALINDROMES.
7. SUPERMAN (AND SUFFICE IT TO SAY, CLARK KENT).
8. POOR-QUALITY BOOTLEGS.
9. THAT SMART-MOUTHED SIMPSON KID.
10. THAT SMART-MOUTHED SIMPSON KID'S GEEKY FRIEND.
11. HEART ATTACKS.
12. THE RESTRAINING ORDER LYNDA CARTER HAS ON ME.
13. BACK TAXES.
14. GETTING OREO MCFLURRY ON THE NEW COMICS SHIPMENT.
15. THE CRETIN ON EBAY WHO KEEPS OUTBIDDING ME ON "DOCTOR WHO" STUFF: EMPERORDALEK42@TARDIS.COM
16. THE POLTROON ON EBAY WHO KEEPS OUTBIDDING ME ON WONDER WOMAN STUFF: DIANASPRINCE361@FANBOY.COM
17. UNSOLD POGS.
18. WWF CHANGING THEIR NAME TO WWE.
19. PEOPLE WHO MISPRONOUNCE *MR. MXYZPTLK*.
20. IGNORAMUSES WHO CALL CAPTAIN MARVEL "SHAZAM."
21. NO OSCAR CATEGORY FOR "BEST MONSTER."

GUY'S BOTTOM 40

2. THE LAST TWO *MATRIX* FILMS. (NOT THAT I'D ADMIT THIS TO A PRIEST.)
3. PARAMOUNT FAILING TO GET BACK TO ME ABOUT MY "XENA VS. STAR TREK: THE NEXT GENERATION" SCRIPT.
4. THE UNTIMELY DEATH OF GWEN STACY (WHICH TO THIS DAY, PAINS ME DEEPLY).
5. PERSONAL JET PACKS NEVER BECOMING A REALITY.
6. SHORT-PACKED ACTION FIGURES.
7. NERDS.
8. THE ZIT ON MY RIGHT BUTTOCK THAT HAS REFUSED TO GO AWAY SINCE THE HALCYON IMAGE COMICS DAYS OF *1993*.

29. NOT BEING ABLE TO FIT INTO THE COMIC BOOK CHARACTER T-SHIRTS FROM MY YOUTH.
30. THAT CLOD IN SALES AT MARVEL COMICS WHO KEEPS HANGING UP ON ME.
31. GEORGE LAZENBY AS *007*.
32. NO TITANOSAURUS IN THE *GODZILLA* PLAYSTATION *2* GAME.
33. INCOMPLETE RUNS.
34. *BICLOPS* COMICS PUBLISHED BY LENSCRAFTERS.
35. INTERNET KNOW-IT-ALLS.
36. BEING TOO OLD FOR NATALIE PORTMAN.
37. NO HARD EVIDENCE OF MY *1987* ALIEN ABDUCTION.
38. COPYRIGHT LAW.
39. NOT BEING COMIC BOOK PROFESSIONAL GUY.
40. VIRGINITY, CURSED VIRGINITY.